COROT

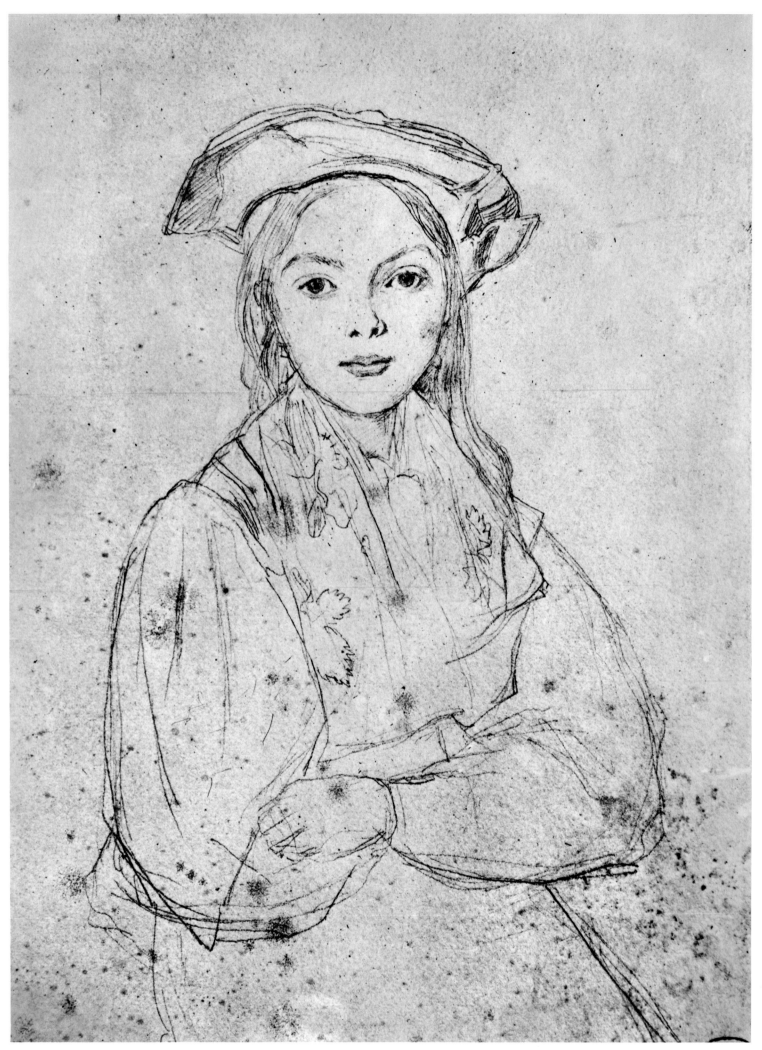

Young Girl with Beret. c. 1831. Pencil on yellow paper, $11^3/_8 \times 8^3/_4''$. Musée des Beaux-Arts, Lille

JEAN-BAPTISTE-CAMILLE

COROT

MADELEINE HOURS

Maître de Recherche au C.N.R.S., Conservateur en Chef au Musée du Louvre

HARRY N. ABRAMS, INC. *Publishers* NEW YORK

ISBN 0-8109-0796-8
Library of Congress Catalog Card Number: 83-72129

Published in 1984 by Harry N. Abrams, Incorporated, New York.
Also published in a leatherbound edition for The Easton Press,
Norwalk, Connecticut. All rights reserved. This is a concise edition
of Madeleine Hours's *Corot*, originally published in 1970.
No part of the contents of this book may be reproduced without
the written permission of the publisher.

Printed and bound in Japan

CONTENTS

COLORPLATES

COROT

CORUT

FEW NAMES IN FRENCH PAINTING are more famous than Corot's. His poetic landscapes in which nymphs dance beside ponds in the forest enjoyed great popularity, and thousands of imitations were produced during his lifetime and shortly after his death. Yet his was a versatile talent, and many aspects of it still go unrecognized. Through his works we shall try to gain better insight into the man, the simplicity of whose life may have been more apparent than real. The fact that its main events can be set down in a few lines has always disconcerted art historians. All of them, however, recognize his exquisite kindness and nobility of character.

Family Background and Early Years

Jean-Baptiste-Camille Corot was born in Paris on July 16, 1796, Year IV of the First Republic, during the Directoire. The house where he was born was situated at the corner of the Rue du Bac and the Quai Voltaire. The original structure was de-

molished in the nineteenth century and replaced by another, but the site has scarcely changed, and the view from the Corot apartment and from Mme Corot's millinery shop would have been much the same as today. The trees in the Tuileries gardens already shaded the quais on the right bank of the Seine, and today The Louvre has regained the beautiful light color that it had at the beginning of

FIGURE 1. View of the Louvre across the Seine

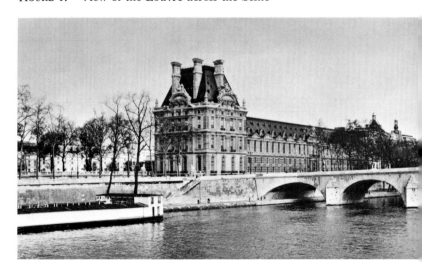

9

the nineteenth century, when the artist was a child.

It is natural to suppose that growing up in so attractive a setting—and it is where Corot spent the first thirty years of his life—considerably influenced his career. The Tuileries gardens, The Louvre, the banks of the Seine contributed to his artistic development; such youthful impressions are indelible. It is the same in Corot as in Nicolas Poussin. Throughout the works of both we find the setting of trees and water against which they lived their childhoods, a setting conceived under the Old Regime and which the Revolution was not greatly to alter.

Corot's mother, who came from Versailles where her family were prosperous wine merchants, had probably been much impressed by the refinement of the society surrounding Marie Antoinette, and it was perhaps there that Mlle Oberson, the future Mme Corot, wife of a rather dull cloth dealer, acquired her taste for elegance. In Paris she ran a well-known millinery shop patronized by fashionable women during the Directoire and the Empire. Jean-Baptiste-Camille kept a respectful fondness for his mother throughout his life, and never spoke of her to his friends except as *"la belle dame."* Shortly after his birth he was put out to nurse for a short period, and when old enough, he was enrolled in a small school in the Rue Vaugirard, where he remained until 1806. Thereupon his parents sent him to the Collège de Rouen, where he took the classical course of studies and formed solid friendships that lasted for the rest of his life.

A certain M. Sennegon, a friend of his parents in Rouen, was charged to look after the boy, and there is no doubt that he had a determining influence on Corot's development. M. Sennegon was a man of the eighteenth century, very likely imbued with the culture of the Encyclopedists. He loved nature and knew how to communicate this love to the boy. Apparently Corot immediately became attached to the Sennegon family, and it was to them he owed his fondness for life out-of-doors—a pantheistic love of

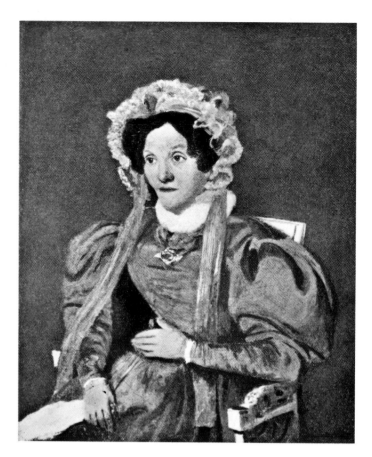

FIGURE 2. *The Artist's Mother.* c. 1845. Oil on canvas, 15¹/₂ × 12³/₈″. National Gallery of Scotland, Edinburgh

nature in the manner of Rousseau—and also a profound sense of human dignity. This latter attitude, deriving from a rather literary conception of ancient Stoicism, certainly contributed to that smiling appearance from which Corot seldom departed and that kept him aloof from Romanticism.

He completed his formal education—not brilliantly, it would seem—at a boarding school in Poissy near Paris, and at the age of nineteen returned home. From now—we are in 1815, just after the collapse of the Empire—until 1822, Corot, although dreaming of being a painter, will be placed in apprenticeship to a series of cloth merchants, business colleagues of his father. The first was Ratier in the Rue de Richelieu, the second Delalain in the Rue Saint-Honoré. The young man managed to get himself liked by his employers, although, it must be confessed, he was less than satisfactory at his job,

making sketches and drawings when he was supposed to be making deliveries, and ruining good pieces of fabric with his paints. Beginning in 1817, he devoted all his evenings to painting, attending the Académie Suisse (named for its director, Père Suisse) on the Quai des Orfèvres. On Sundays he divided his time between his parents and the practice of his art. In the same year, his father bought a country house at Ville-d'Avray, about ten miles from Paris, in a pleasant region of woods and ponds. Camille Corot was enchanted by the eighteenth-century house, and his rediscovery of the joys of an intimate communion with nature heightened his pleasure in painting.

When he was not at Ville-d'Avray, Corot spent his evenings in Paris striding fervently along the quais of the Seine, and, coming home, tirelessly reiterating his wish to become a painter. Toward the end of his life, he related with warmth and simplicity the joy he had felt when his father, tired of hearing him complain of having to work for the fabric dealers, asked him what plans he had for his future. This was in 1822, when Corot was twenty-six. He said firmly, "I want to be a painter." His father

FIGURE 3. Corot house, Ville-d'Avray

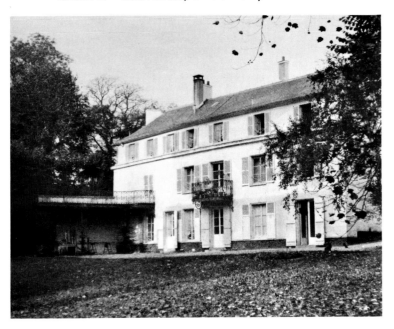

decided to comply with his wish, and granted him the allowance he had previously given the younger daughter, Victoire-Anne, who had recently died. Camille was overjoyed and went for a walk along the quais. Many years later, he confided to a friend: "I was wild with joy, my brain was on fire." He ran to ask the advice of his friend and teacher, Achille-Etna Michallon. Soon he set himself up at 15 Quai Voltaire, just a stone's throw from his beloved family, and in 1823 proudly received his friends in his first studio.

What, in essence, do we know about this artist as a young man? Very little, apart from the fact that even in his early years he is far removed from extremes. Aside from his devotion to art, there is nothing violent or passionate in him. He has been brought up by enlightened eighteenth-century burghers, and has been imbued at an early age with a pantheistic love of nature. From his mother—whose family, the Obersons, had come from the Fribourg canton in Switzerland but were attached to Versailles—he has inherited his innate orderliness, his sense of color and harmony. From his father's family, Burgundian in origin, he has inherited his vitality, his strength, and a certain physical equilibrium. At the Collège de Rouen he has acquired a culture that is more thorough, more literary, more poetic and profound than might be inferred from his outward behavior. His love of painting, long held in check and never understood by his family, has given him a reserved, somewhat restrained air, and the habit of keeping still and looking about him with all the intensity of which a young man of his temperament is capable.

The Making of an Artist

It was thus that Camille Corot, at the age of twenty-six, officially embarked on the study of painting. Of course, he was already familiar with The

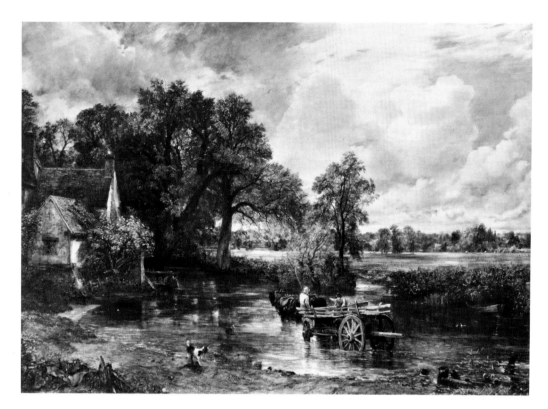

FIGURE 4. Constable. *The Hay Wain*. 1821.
Oil on canvas, 50¹/₂ × 73".
National Gallery, London

▶

FIGURE 6. Detail of *Self-Portrait*.

FIGURE 5. *Woman of Dieppe*. 1823.
Paper mounted on canvas, 11 × 6¹/₄".
Musée des Beaux-Arts, Lyons

Louvre, practically on his doorstep, and surely by
then had read the treatise by Pierre-Henri Valen-
ciennes, *Eléments de perspective pratique à l'usage des
artistes, suivis de réflexions et conseils à un élève sur la
peinture et particulièrement sur le genre de paysage* (Ele-
ments of Practical Perspective for Use by Artists,
Followed by Reflections and Advice to a Pupil Con-
cerning Painting, Especially the Landscape Genre).
This treatise was much discussed when it was pub-
lished in 1800, so much so that sixteen years later
the Academy established a Prix de Rome for his-
torical landscape. David was still painting in Brus-
sels, where he lived in exile until his death in 1825,
Ingres was preparing the *Apotheosis of Homer*, and
Fragonard had died in The Louvre in 1806. At the
Salon of 1824, Corot pored over the English land-
scape painters whose work was then new. Copley
Fielding and Bonington exhibited four outdoor
studies (including two seascapes), and Constable his
Hay Wain (fig. 4), which Germain Bazin believes to
have had a particular influence on Corot, still to be
discerned in a painting he executed at Fontaine-

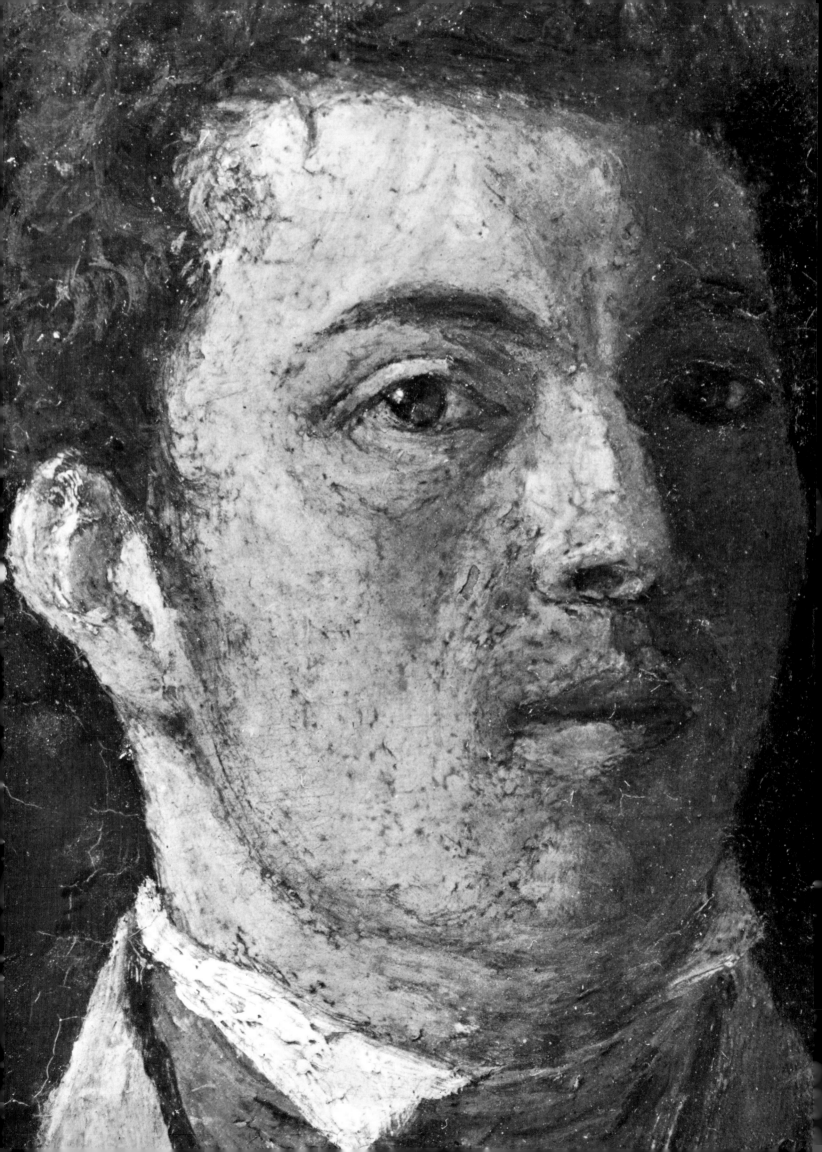

bleau twenty years later. At the same Salon of 1824, Delacroix exhibited his *Massacre of Chios*. Delacroix was only two years younger than Corot and, although the two artists did not meet until much later, each was to have a high esteem for the other.

As early as 1822, Corot had received advice from Michallon—before the latter's premature death— advice he was never to forget: "Look closely and be truthful in rendering nature." Michallon was then back from Rome, where he had gone on an Academy fellowship awarded for his landscapes. Born like Corot in 1796, he died in 1828 shortly after leaving Bertin's studio. Corot, in his turn, went there to study.

Jean-Victor Bertin belonged to the Neoclassical school of landscape, in the tradition of Claude Lorrain and Poussin. This tradition had lasted throughout the eighteenth century, and, given fresh impetus by Valenciennes, found official recognition in France at the beginning of the nineteenth century. Parallel with this traditional school, there developed a freer conception of landscape painting, which derived from the theories of Jean-Jacques Rousseau and tended to depict village scenes and picturesque views with a certain affectation and naïveté. Moreau

the Elder and Demarne are the best representatives of this tendency. The English landscapists, when related to this group of artists, surpass them, owing to the genuineness and lack of affectation in their feeling for nature.

Corot worked with Bertin but it is hard to say what he retained, except a respect for Poussin, a concern for careful composition and drawing, and an interest in certain historical and literary aspects of the subjects treated.

At the same time, Corot pursued his new-found freedom by taking solitary walks in the country, pencil or brush in hand, and sketching directly from nature. It is from this period prior to the first trip to Rome that Alfred Robaut dates a number of *pochades* (quick sketches), both landscapes and touching little figures, of which *Boy in a Top Hat* (private collection, Paris) and *Woman of Dieppe* (fig. 5) are the most moving.

A trip to Rome was the natural sequel and indispensable complement to his Neoclassical studies under Bertin. Michallon's enthusiasm for the Roman *campagna,* and the marvelous notations that Valenciennes, the theorist of landscape painting, had brought back from Italy at the close of the eighteenth century, combined to whet the young Corot's desire to go to Italy. In 1825, his parents approved the trip on condition that he leave behind a portrait of himself. This self-portrait (detail fig. 6), now in The Louvre, is the product of anxious observation. Its reworkings, its impasto, its somewhat awkward technique bring to mind French portraitists of the sixteenth and seventeenth centuries. The young painter is twenty-nine, but seems stiff and rather heavy-handed before his canvas.

Corot exchanged the banks of the Seine for those of the Tiber, and in Rome renewed his ties with the French Neoclassical tradition represented by Valenciennes and Michallon, and with the older tradition of Poussin and Claude Lorrain. Long neglected, Corot's Italian landscapes are today the most sought after, although they gained him little encourage-

FIGURE 7. Valenciennes. *At the Villa Farnese.* c. 1786. Oil on paper on cardboard, 10 × 14⁷/₈″. The Louvre, Paris

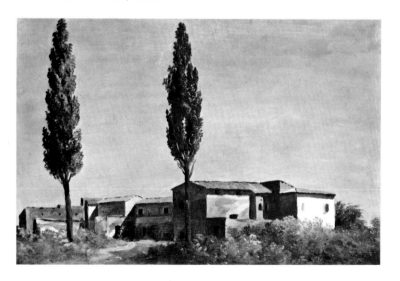

FIGURE 8. Poussin. *Winter* (*The Deluge*). 1660–64.
Oil on canvas, 46$^1/_8$ × 63".
The Louvre, Paris

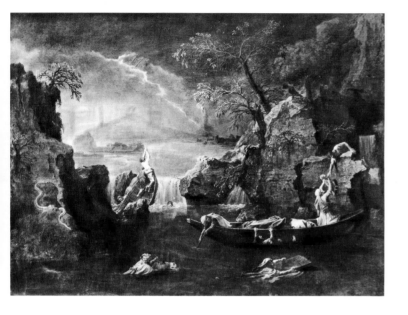

FIGURE 9. Claude Lorrain. *The Forum*. c. 1660.
Oil on canvas, 22 × 28$^3/_8$".
The Louvre, Paris

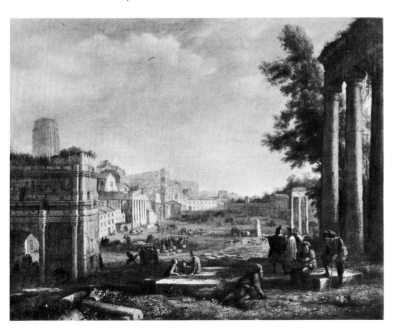

ment at the time. He received some, however, from his traveling companion Caruelle d'Aligny, an excellent landscapist who, with his rather dry technique, was to make felicitous renderings of Italian sites and monuments.

Getting quickly to work by the end of 1825, Corot was to execute many sketches from nature, on canvas, wood, or cardboard, and most of them of small dimensions. Some were to be reworked in his studio in Rome and later in Paris. For three years, moving back and forth between Rome and Naples, in the woods around Papigno, on the banks of the Nera, at the foot of ancient monuments, Corot was to study Italy, the science of composition, and that taste for order for which he had already had a strong inclination imparted to him by the noble perspectives of The Louvre and the Tuileries. In Rome he would perfect his gift for rendering the subtlest values. To be sure, he visited the museums, but he preferred the study of the *plein air* and his own vision to that of others, however great they may have been. It was in 1826–27 that this dialogue between man and nature—the most intimate there has been in painting—was begun, and to the day of his death Corot never let it be interrupted either by passion or any kind of worldly concerns.

In September, 1828, he was back with his family and such childhood friends as Abel Osmond, Faulte du Puyparlier, and Alexandre Clérambault, not to mention the charming seamstresses employed in Mme Corot's shop—among them Alexina Ledoux, whose portrait (colorplate p. 54) he painted some two years later. This work brings to mind Clouet, with its short and precise brushstrokes and the rather abrupt transitions between dark and light.

Alexina was perhaps the most serious love of his life, but he seems to have sacrificed even her to his painting. Be that as it may, neither affection for his parents nor love for Alexina prevented him from going away again, to Fontainebleau, to Chartres, to Normandy and Brittany. In 1830, he remained in Paris until the July Revolution drove him to Chartres.

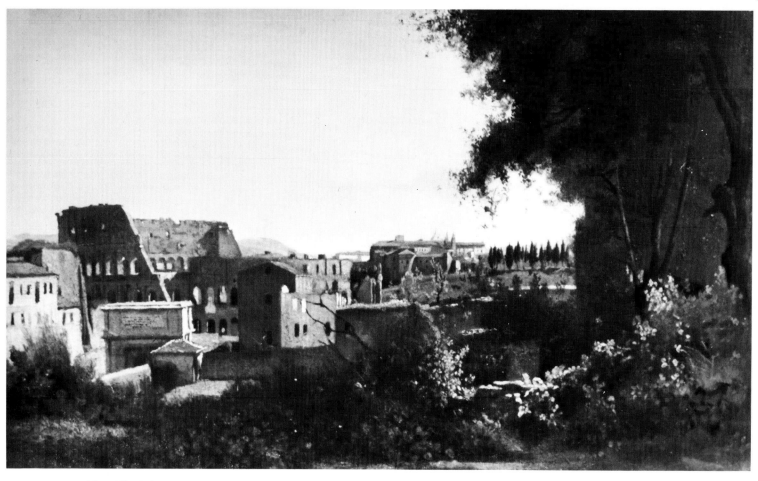

FIGURE 10. *The Colosseum Seen from the Farnese Gardens*. 1826. Oil on paper mounted on canvas, 11 × 18⁷/₈″. The Louvre, Paris

FIGURE 11. *View from the Farnese Gardens, Rome*. 1826. Oil on canvas, 9¹/₂ × 15³/₄″. The Phillips Collection, Washington, D.C.

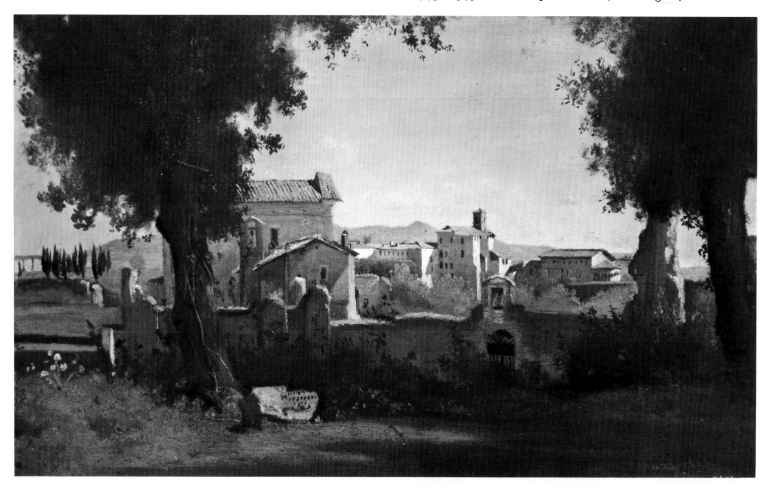

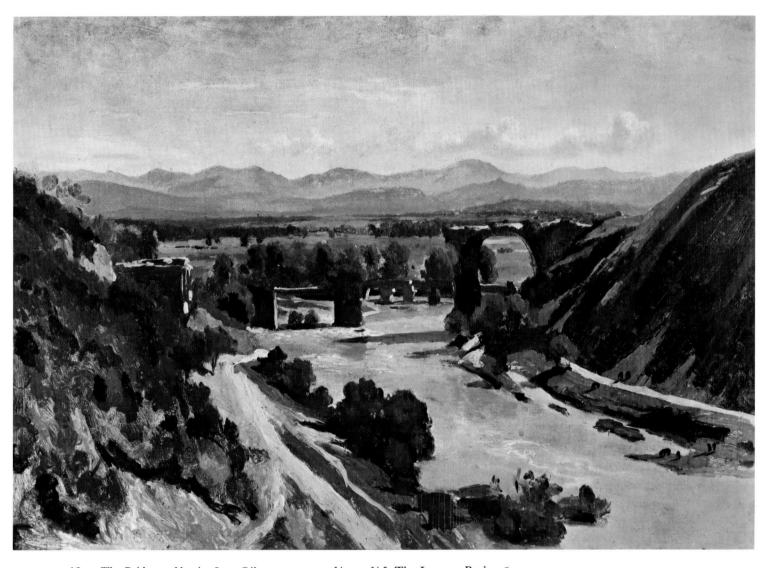

FIGURE 12. *The Bridge at Narni*. 1827. Oil on canvas, $14^1/_8 \times 19^5/_8$″. The Louvre, Paris

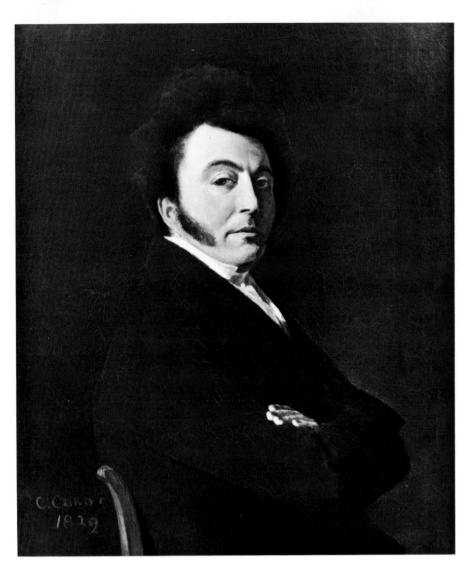

FIGURE 13. *Portrait of Abel Osmond.* 1829.
Oil on canvas, 20³/₄ × 17¹/₄".
Collection Dr. Marjorie Lewisohn, New York City

▶

FIGURE 14. *Mlle Alexina Ledoux* (detail). c. 1830.
The Louvre, Paris

Afterwards he continued to divide his time between his studio on the Quai Voltaire in winter and excursions to the provinces in summer. *Chartres Cathedral* (colorplate p. 52) is his masterpiece from this period; in it we can measure the perfection of the drawing and the preference for clear values, the subtlest nuances of which are rendered with a supple technique.

From time to time Corot would return to stay with his family, usually at Ville-d'Avray—after the banks of the Seine, this was the place he cherished most. By his own account, this village had a more lasting influence than any other place upon his artistic development. "Providence created Ville-d'Avray for Corot, and Corot for Ville-d'Avray," Etienne Moreau-Nélaton observed. The Corots' house there dated from the end of the eighteenth century, and

had been a "*folie*" built for a fashionable courtesan by her lover.

The Cabassud houses at Ville-d'Avray, which Corot painted several times with great mastery, have now almost completely disappeared. The site, however, has hardly changed. In the woods surrounding the ponds, Corot took notes and made drawings and sketches. He would go out early in the morning before the mists had been dissipated by the sun. He also liked to work late in the afternoon, after five o'clock, when the evening mists began to gather. The hours of broad daylight he devoted to his parents, to his sister's children, whom he treated as his own, and to afternoon naps. Evenings, after his long walks, he liked to listen to the sounds of nature outside his open window.

Paul Valéry has pointed out how difficult it is to

FIGURE 15. Kiosk in the garden of the Corot house, Ville-d'Avray

speak of Corot's *oeuvre* inasmuch as in him there would seem to be no intellectual intermediary between eye, nature, and the painting itself. "Some painters have doctrines, like Poussin, Delacroix has theories, but in Corot, there is only work and contemplation." In any event that is all there was at Ville-d'Avray, in a house that has hardly changed during more than a century. The summerhouse, or kiosk, where the artist liked to work is still standing; there he was undisturbed by his sister's children— and later her grandchildren—making noise in the main residence. But Corot's heart was big enough to make room for friends, too, the closest of whom in his younger days was certainly Abel Osmond. The Osmonds lived in the village of Rosny, where they owned a château, and later near Saint-Lô. Corot was a frequent visitor to Rosny, going by carriage or

on foot, and he has left us a delightful picture of how the village looked in the early morning. He often stayed at the pink-and-white château, which had once been owned by the Duchesse de Berry and had been painted by Bonington some years earlier.

At the Salon of 1833 Corot exhibited the *Ford in the Forest of Fontainebleau* (present whereabouts unknown). He was then thirty-seven; for this work he received his first official award—a second-class medal. He was happy and proud, as was his family, and this facilitated his second trip to Italy, which, up to this point, his parents had opposed.

They saw their son depart in the company of the painter Grandjean. In the course of this journey, which lasted from May to October, 1834, Corot executed the *View of Genoa from the Promenade of Acqua Sola* (colorplate p. 60) and painted some impressive studies of Venice, where he stayed three weeks. The *View of the Grand Canal and Santa Maria della Salute* (Pushkin Museum, Moscow) is a fine example of Corot's independence—he gives us a tourist's impression, but with a freedom that is all his own. There is a nonconformism in the composition that anticipates twentieth-century painting, a way of involving the observer that is entirely new. This is no longer a view of Venice objectively set down, but a subjective work in which the viewer is drawn into the landscape.

His second trip to Italy also produced the splendid *View of Florence from the Boboli Gardens* (fig. 17), now in The Louvre.

In Corot's second self-portrait (colorplate p. 62), mastery of the human figure is complete. It is enough to compare this picture, one of the treasures of the Uffizi in Florence, with the self-portrait (detail see fig. 6) of 1825 to measure the development of the artist's style. The attitude of the model reveals a dignity, a sense of his own powers, as well as confidence in the destiny he has chosen and paid for so dearly at the price of loneliness. For up to the age of fifty, Corot was to remain solitary and misunderstood. The fame that grew up around the land-

FIGURE 16. *The Forest of Fontainebleau*. c. 1830. Oil on canvas, 69^1/$_8$ × 95^1/$_2$″.
The National Gallery of Art, Washington, D. C. Chester Dale Collection

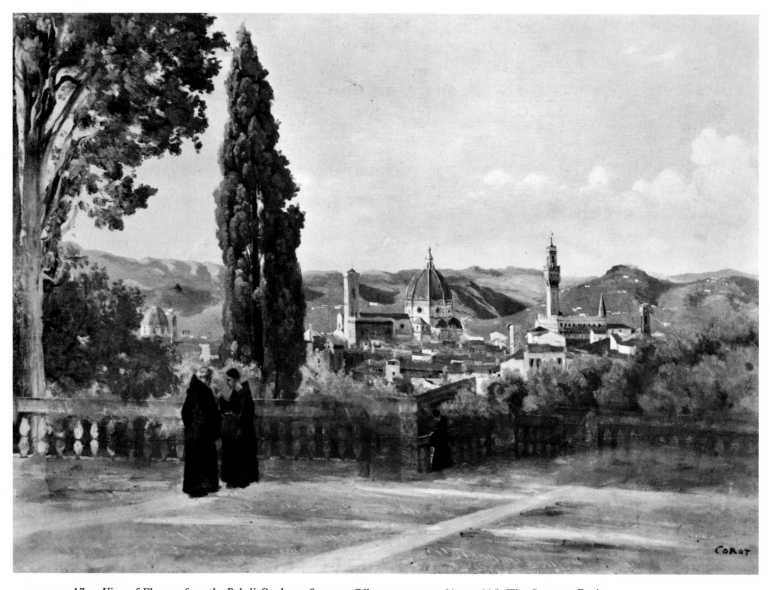

FIGURE 17. *View of Florence from the Boboli Gardens.* 1835–40. Oil on canvas, 20¹/₈ × 29¹/₈″. The Louvre, Paris

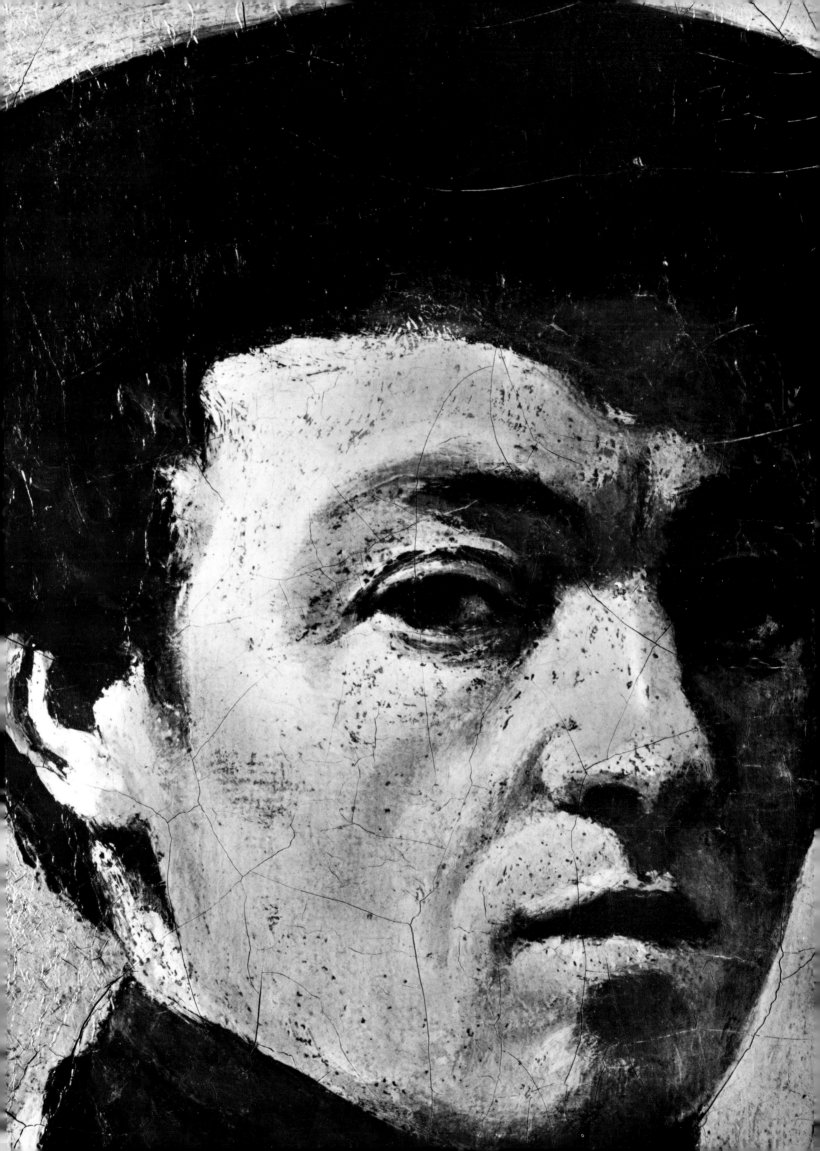

scape painter later must not make us forget the lonely younger man whose talent went unrecognized even by his own family, who labored for thirty years in obscurity, with no reward but his own assurance of being sometimes able to catch the fleeting harmonies produced by the marriage of nature and light.

Maturity and Mastery

Ville-d'Avray, Rosny, Arras, Mortefontaine, and later Mantes were to be the major subjects of Corot's mature painting.

Between 1835 and 1865 Corot was to paint a number of wall decorations, and we must deplore the fact that he only rarely received official commissions. In 1837, he gave a *Saint Jerome* to the church at Ville-d'Avray. Three years later, in the house of the magistrate Louis Robert at Mantes, a cousin of his friend Abel Osmond, he painted a *Flight into Egypt* to be placed in the church at Rosny. But the most important of his decorative works are undoubtedly those he painted on the four walls of the bathroom in the Robert house (fig. 22), which evoke memories of Italy. When we look at them today in The Louvre—where they have been transferred thanks to the generosity of Louis Robert's heirs—we can only be sorry that Corot so seldom had occasion to exercise his gifts for this kind of painting. These compositions reveal a gracefulness that brings to mind Fragonard, a skill in exploiting odd-shaped, broken-up surfaces, and a freedom that is the best proof of the ease with which Corot adapted himself to mural decoration. In 1844, he received an official commission for a *Baptism of Christ* to decorate a chapel at the Church of Saint-Nicolas-du-Chardonnet in Paris. One very detailed preliminary study exists in a private collection, and allows us to measure the influence of Delacroix on the group of figures at the right. In 1865, Corot painted two large compositions for the drawing-room of Prince Demidov: *Orpheus Greeting the Light* and *Diana Sleeping*. At intervals throughout his life he was to execute mural decorations for his friends—for instance, at Daubigny's house in Auvers-sur-Oise, and the Bovys' château in Switzerland. He helped decorate Gérard de Nerval's apartment and the studio of Decamps near Fontainebleau. At Ville-d'Avray he painted four panels for the church and decorations for the summerhouse in the garden of his parents' property.

Corot's third and last visit to Italy was in 1843, a journey that produced *La Marietta* (colorplate p. 68) and *Gardens of the Villa d'Este at Tivoli* (colorplate p. 70). After his return he composed *Homer and the Shepherds* (colorplate p. 74), inspired by André Chénier's poem *L'Aveugle*. The feeling is profoundly Vergilian: Corot's love of nature and his literary education are both apparent here. He gave the painting to the museum of Saint-Lô. Conceived in Normandy at the house of his friends the Osmonds, this work, by its knowing treatment of light, renders the idealized atmosphere of the dawn of the Hellenic world. The critics received it favorably, and in 1846 Corot was given the highest French award, the cross of the Legion of Honor. However, he still found no buyers for his pictures, and this lack of comprehension by the public saddened and afflicted him as much as his family's continuing failure to appreciate the importance of his talent. His father died in 1847, never suspecting that before long his son Camille would be both rich and famous.

Corot's Technique

Corot's mother died in 1851, and shortly afterward he went to stay with his friend Constant Dutilleux at Arras. Subsequently, he scarcely let a year go by without a visit there. The Dutilleuxes became a second family to him, and it was through them that he met Alfred Robaut, who was to become his

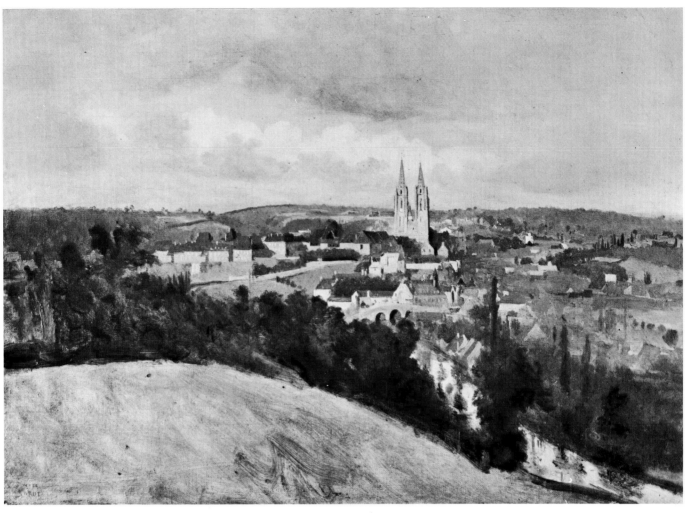

FIGURE 19. *View of Saint-Lô*. 1850–55. Oil on canvas, 18¹/₈ × 25¹/₄".
The Louvre, Paris

biographer and spiritual son. There can be no doubt that Corot found at Arras not only understanding but success. The damp climate of northern France, the subtlety of the light filtered and diffused by the mists and fog, encouraged Corot to renew his technique, his palette, his subject, even his attitude toward his subject. Hitherto he had combined a classical approach with a subjective realism already imbued with a personal and poetic sentiment. Between 1830 and 1851, the high points of this phase are *Chartres Cathedral*, *Self-Portrait with Palette*, *La Marietta*, *Gardens of the Villa d'Este at Tivoli*, *Portrait of Mme Charmois*, and *The Port of La Rochelle*. Beginning in 1850, the artist was often to replace these views of nature by poetic compositions involving not only a change in technique but likewise a psychological transformation. *Morning: Dance of the Nymphs* (colorplate p.82), exhibited at the Salon of

1850–51, is a good example. We have preliminary studies for the little figures that enliven this composition: exquisite silhouettes that the artist put down in his sketchbooks while attending the Opéra, which, along with the Comédie-Française, he attended several evenings a week. *Morning: Dance of the Nymphs* seems to be a synthesis of his Italian recollections and his discovery of the subtle light of northern France. In this light, contours become blurred and values increasingly subtle, leading to the silvery palette of his *Souvenir* (Recollection) series, pictures executed in the studio from preparatory studies in the open air.

We know that Corot was always very fond of music, that he attended concerts regularly, and had a special fondness for Gluck. From 1850 on, music becomes a leitmotiv of his art, as does his sentiment of melancholy. The death of his parents, his loneli-

25

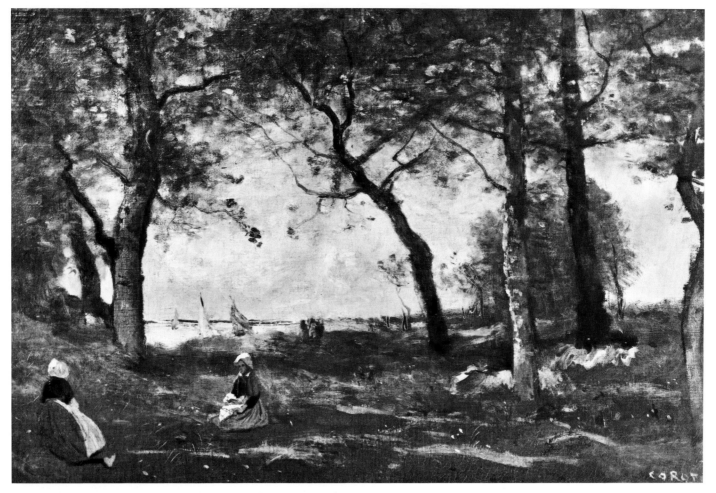

FIGURE 20. *Honfleur—View of the Sea Through Trees.* 1855–70. Oil on canvas, 22⁷/₈ × 15³/₈″. Musée des Beaux-Arts, Reims

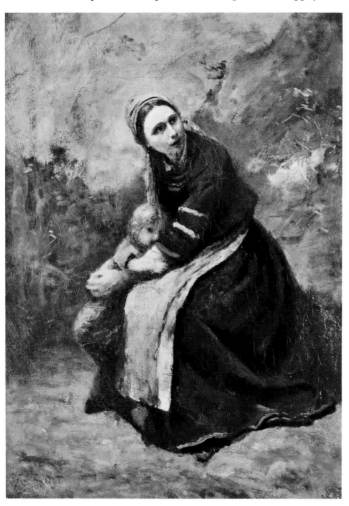

FIGURE 21. *Mother Protecting Her Child.* 1855–58.
Oil on canvas, 20 × 14¹/₄″.
Philadelphia Museum of Art. The John D. McIlhenny Collection

ness, the long hard struggle for recognition, and perhaps his own self-doubt combined to produce a secret melancholy in this joyful, friendly man, an inclination for reverie that maturity and consciousness of his mastery enabled him to liberate and transform into painting with a subtlety all his own.

One can discern the evolution of this attitude in his style and in his technique. If we compare a series of works executed after his first youth with ones dating from his maturity and old age, we can, with the aid of optical procedures available today, clearly see the transformation of the painter's style, a softening of contours which, precise and sometimes even emphasized by dark lines in the early works, gradually become lighter by a succession of almost imperceptible transitions, until they are dissolved by the light that suffuses them in the painter's old age—for example, the figures in *The Studio: Young Woman with a Mandolin* (colorplate p.

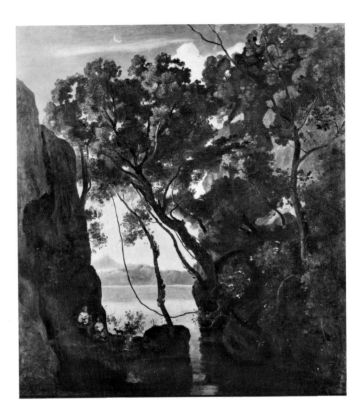

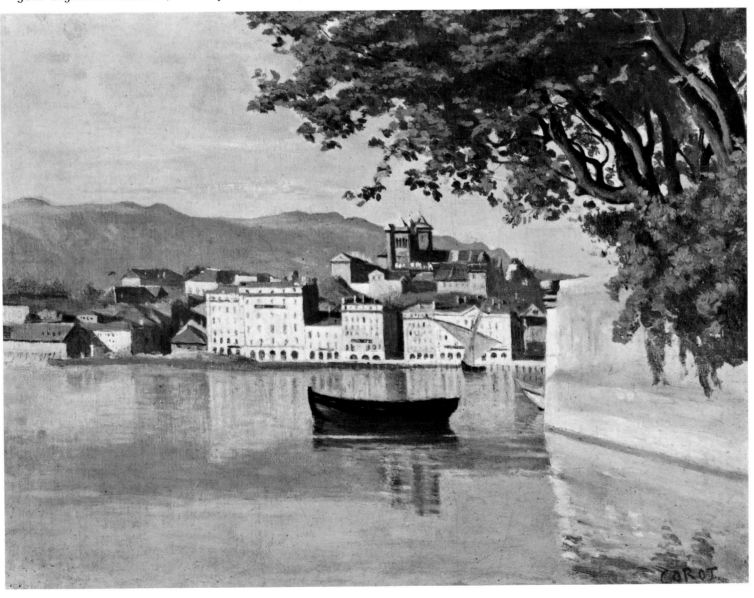

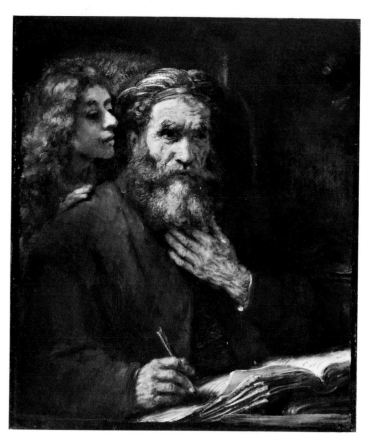

FIGURE 24. *Saint Sebastian* (detail). 1850–51. The Louvre, Paris

FIGURE 25. Rembrandt. *Saint Matthew and the Angel*. 1661. Oil on canvas, $37^3/_4 \times 31^7/_8''$. The Louvre, Paris

104) and *Saint Sebastian* (colorplate p. 86). The brushwork itself evolves: around 1830, Corot was using a fairly short, firm stroke; gradually it becomes broader and more flexible, at the same time that his palette becomes more subtle and harmonious, although the number of colors is actually reduced. In this respect, Corot's development parallels that of Rembrandt, as is even more apparent in his figures than in his landscapes.

The transformation of Corot's painting around 1850, especially his tendency to lyrical interpretation of landscape, implies great mastery and underscores the diversity of his talent. This is not to arrange his works in any particular scale of quality. Far be it from me to suggest that the poetic landscapes, the recollections of Mortefontaine and Ville-d'Avray, are superior or inferior to the masterpieces of his classical period. This would be to misinterpret Corot, who never ceased in his painstaking cultivation of landscape painting from nature, with a freedom that was from the beginning

his own. Two paintings, the *Bridge at Mantes* executed about 1868–69 and *The Belfry of Douai* (colorplate p. 116), must be looked upon as particular peaks in Corot's production. The painter knew this himself, and wrote on May 8, 1871: "I am putting the final touches on *The Belfry of Douai*—it's terrific."

Once the critics began—from 1846 on—to notice him favorably, Corot gradually achieved wider recognition, though the process was slow on the part of both the public and the official authorities. In 1847, he received professional encouragement from two important sources. Constant Dutilleux, a printer, lithographer, and painter, who was perhaps more clear-sighted than talented, called on him and assured him of his admiration—a passionate admiration which was to be shared by Dutilleux's family. In addition, Constant Dutilleux was surely responsible for the meeting between Corot and Delacroix, being as he was an enthusiastic friend of both painters. It cannot be by chance that in that same year Delacroix called on Corot and expressed

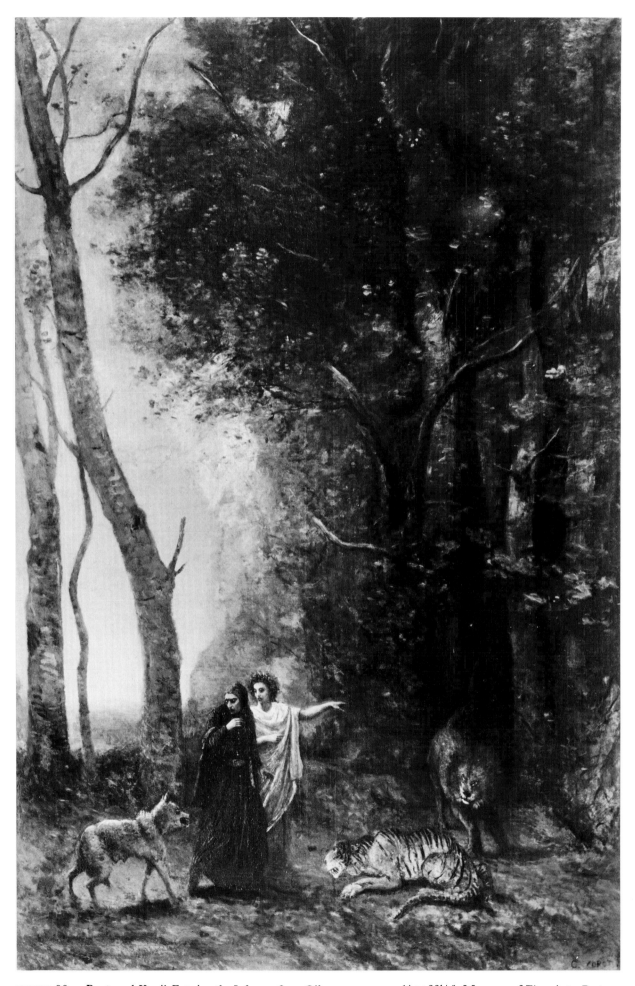

FIGURE 26. *Dante and Vergil Entering the Inferno.* 1859. Oil on canvas, 101^1/$_2$×66^1/$_4$″. Museum of Fine Arts, Boston

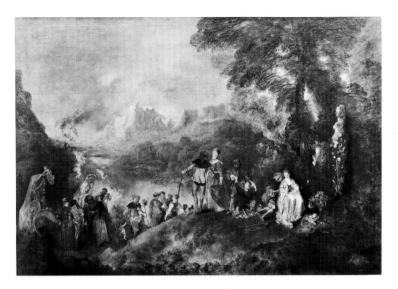

FIGURE 27. Watteau. *Embarkation for Cythera*. 1717. Oil on canvas, 50¹/₂ × 76″. The Louvre, Paris

admiration for his art. The meetings between the two artists were constructive: Corot gave Delacroix a few hints on "how to handle a tree," and at the same time was himself drawn to a more poetic, more literary conception of painting, one closer to Romanticism, as we see by the titles of certain works, such as *Dante and Vergil Entering the Inferno* (fig. 26), painted in 1859.

In 1855, Napoleon III purchased *Recollection of Marcoussis*. During the next twenty years, Corot would alternate between landscapes painted out-of-doors (such as *The Church of Marissel*, colorplate p. 110) and studio compositions, landscapes in which reality is combined with an inner poetic feeling that brings about a delicate transcription of the fleeting rays of dawn or sunset on an idyllic scene peopled with nymphs and shepherdesses. One of the most successful of these compositions is *Recollection of Morte-fontaine* (colorplate p. 100), which Corot executed in 1864 on the basis of studies made at this poetic spot. Mortefontaine is situated eighteen miles north of Paris, in a region of extensive woods with ponds and clearings. Watteau had stayed there for long periods one hundred and fifty years earlier, and the setting inspired his masterpiece, the *Embarkation for Cythera* (fig. 27). The affinity between this work, the triumph of French painting of the early eighteenth century, and Corot's picture is obvious.

The infatuation of the Second Empire with eighteenth-century art partially accounts for the sudden passion that collectors felt for Corot's poetic landscapes. "*Recollection of Mortefontaine* represents one stage in Corot's career, a crystallization of his past. The form of this picture came into being on the brink of old age, like a distillation of thirty years of his life," Germain Bazin has written. Several variants of this painting are extant; the same is true of the series of paintings that grew out of *Morning: Dance of the Nymphs*. Among the replicas of these admirable compositions we sometimes find less accomplished works, only partly by Corot's hand, works in which the poetic feeling is diluted and the theme dulled by excessive use, like the plate of an engraving too often reproduced, where the vigor and evocative power are in inverse proportion to the number of copies in circulation.

With success came wealth, but Corot did not change his way of life. His family allowance remained enough for his needs, but he discovered the pleasure of generous giving, and this charitable impulse sometimes made him act a little too hastily to satisfy impatient collectors. Because of his proverbial generosity, the elderly Corot is sometimes pictured as following in the footsteps of Saint Francis of Assisi or Saint Vincent de Paul. However, the image of the smiling grandfatherly painter drawn by his biographers seems to be only partially true. Photographs of Corot (fig. 29) reveal an attitude of great dignity, and a powerful face with firm features, the expression severe, with nothing banal or common about it. Henri Rouart, who knew him well, said that he was "naturally kind and gay, but in his features happiness was tinged with melancholy; success had come late." His supposed rusticity was more seeming than real. The courteous, straightforward style of his letters (fig. 30) further attests to his innate dignity. A series of these notes, of the kind he wrote daily to his friends and pupils, has recently come to light. This is Corot's correspondence with Achille-François Oudinot, a follower during the last years, who emigrated to Boston after the master's

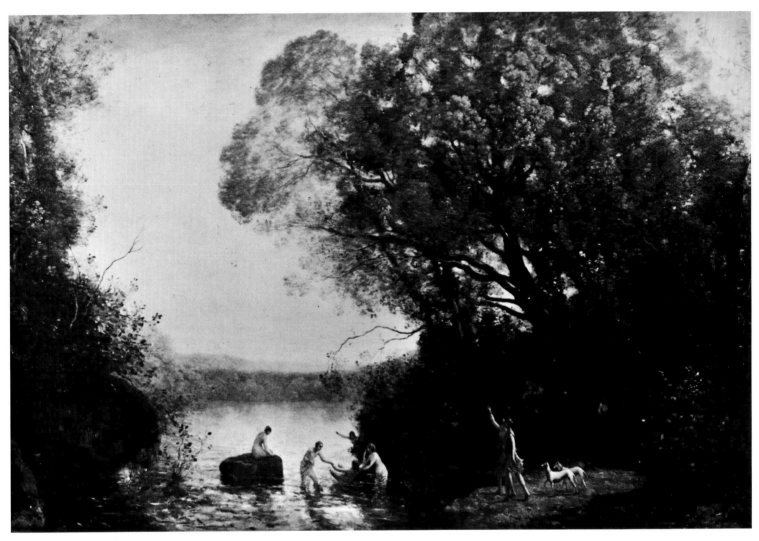

FIGURE 28.　*Diana's Bath*. 1855. Oil on canvas, 66¹/₈ × 101¹/₈″. Musée des Beaux-Arts, Bordeaux

 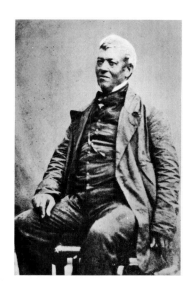

FIGURE 29. Photographs of Corot. c. 1853. Collection Robaut-Dutilleux

death. One of the texts most revealing of Corot's noble generosity is a letter addressed to Daubigny, quoted by Moreau-Nélaton. Honoré Daumier was a sick old man living in a damp and dilapidated house at Valmondois, which his landlord refused to heat until Daumier paid his back rent. Corot had a new floor installed in the room at his own expense and wrote to Daubigny, who was a neighbor of Daumier's: "Now we must get the landlord off that old fellow's back. Buy the house, the money is enclosed." Tears came to Daumier's eyes on hearing the news, and he expressed his gratitude by sending Corot one of his paintings. Corot was enchanted with the gift and hung it over his bed, both because he liked it and as a reminder of his good deed. There was more than one incident of this kind: Corot's studio at 58 Rue Paradis Poissonnière, where he had moved in 1853, saw an endless procession of friends, pupils, and petitioners. At the same time he worked hard to turn out the poetic landscapes for which there was such demand. The attic of the building (which, incidentally, is still standing) served as his storeroom.

The Figure Painter

Along with his landscapes, Corot applied himself after 1850 to the execution of large figure paintings. He had been interested in figure studies from the

FIGURE 30. Facsimile of a letter by Corot. Collection the author

My dear Oudinot,

It was Flahaut's idea. He gave the piece to me and I was very glad to be able to give it a few touches, so that it could be placed. It is for a very impatient gentleman who absolutely wanted one of my pictures. All this seems perfect to me, and think how happy I am to have been able, with a tender touch, to deliver it and give you the profit. Therefore I keep the object at your disposal.

Sincerely yours,
C. COROT

This Wednesday

outset of his career. In Italy he made numerous quick sketches of young women and boys. Beginning around 1830, he executed a great many portraits of his family and friends, usually on small canvases. These works demonstrate the closest observation, meticulous execution, and great sincerity. Between 1843 and 1857 his preferred portrait subjects were young children. We can perceive the artist's tender feelings for his models. Surely one of the most successful of these portraits is that of Maurice Robert as a boy (colorplate p. 94). Macrophotography (fig. 32) reveals the lightness of brushstroke, the freshness of pigment. Few French painters have better conveyed the frailty and vulnerability of childhood. Here as elsewhere Corot is heir to Chardin and to the Le Nains who, since the seventeenth century, had known how to bring out the grace possessed by even the most ill-favored child.

About 1850, Corot executed one of his finest female figures, inaugurating a series of half-length portraits painted for pleasure in the studio. *The Fair Maid of Gascony* (colorplate p. 80) has a serene strength, an almost sculptural solidity unique in nineteenth-century painting. Figures of such power and aloofness will not be found again until Picasso's monumental figures of 1923–24. Picasso's *Femme Assise* of 1923 (fig. 33) and the *Greek Woman* of 1924 (Collection Alex Maguy, Paris) are sisters to Corot's *Fair Maid of Gascony*; all three exhibit the same broad brush stroke, a soft flat pigment, and the same palette.

FIGURE 31. *Italian Peasant Boy.* 1825–26. Oil on canvas, 10 × 12⁷/₈″.
The National Gallery of Art, Washington, D.C. Chester Dale Collection

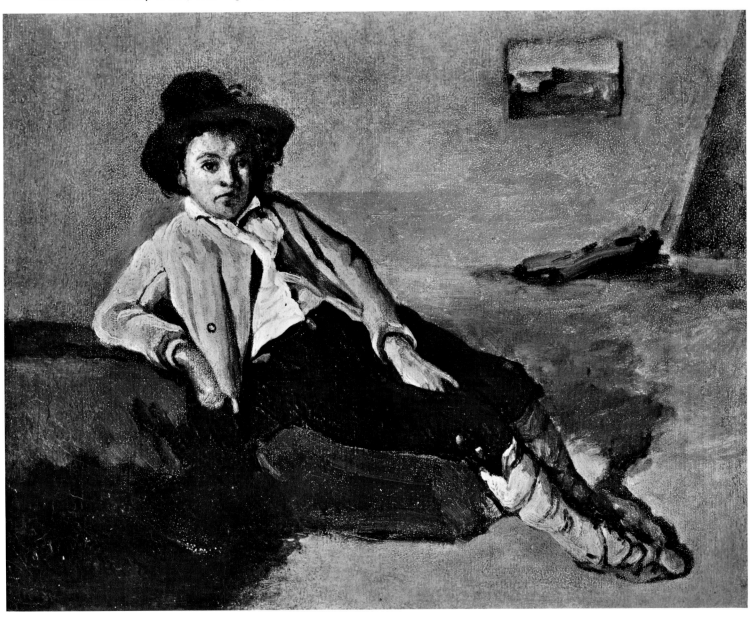

These features also characterize the works Corot executed fifteen or twenty years after *The Fair Maid of Gascony*; for instance, *The Muse—Comedy* (fig. 37) and *The Sibyl* (painted 1865–70), both in The Metropolitan Museum of Art, New York. These figure studies were executed from models whom Corot dressed in theater costumes borrowed from his friend Edouard Brandon. The compositions are extremely varied. In some of them the pose is very natural, giving the impression of a snapshot: for instance, the *Young Girl at Her Toilet* (Museo Nacional, Bogotá). It is possible that the discovery of photography affected Corot as much as it did other nineteenth-century painters. Among the large figure paintings there is only one group, the *Mother and Child on the Beach*

(colorplate p. 98), painted about 1860. Here again we find the monumental fullness of forms already seen in *The Fair Maid of Gascony*. The circular composition formed by mother and child strengthens the expression by binding the figures closely together. This is one of Corot's boldest compositions.

The studio in the Rue Paradis Poissonnière, where Corot worked off and on for the rest of his life, provided the background for several paintings in which the model appears to muse or daydream before a canvas on the easel. The attitude and melancholy expression of the young woman holding a musical instrument recur with many variations in these works, whose common subject is "The Artist's

FIGURE 32. *Maurice Robert as a Child* (detail). 1857. The Louvre, Paris

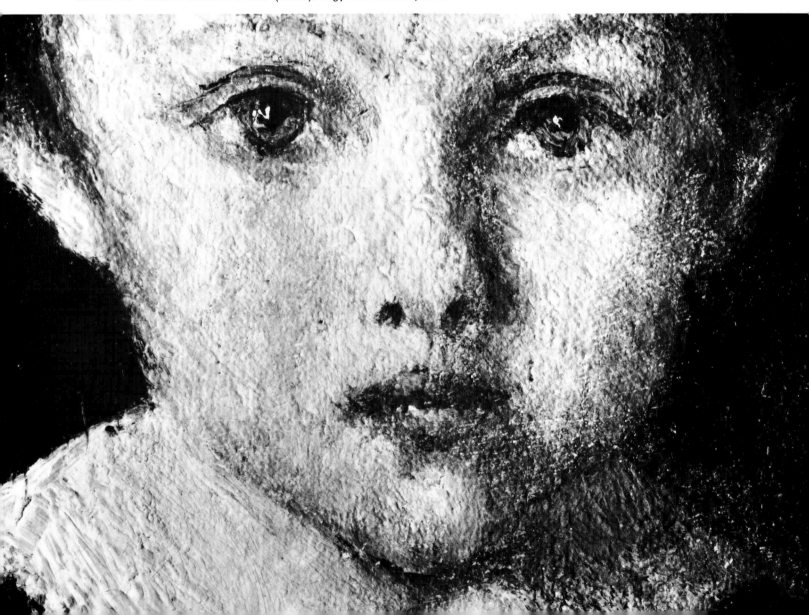

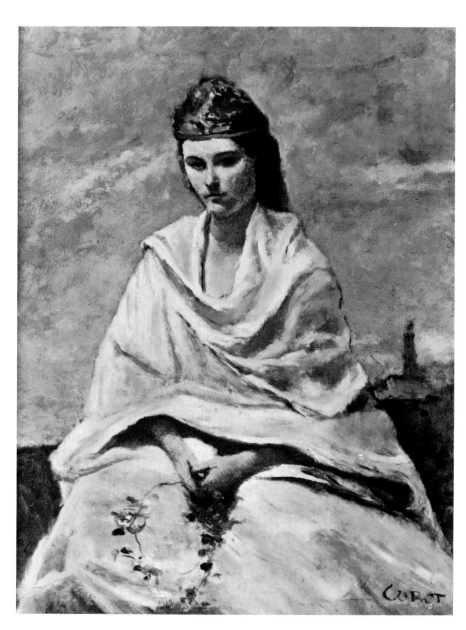

FIGURE 34. *Greek Girl*. 1868–70.
Oil on canvas, $20^1/_2 \times 15^1/_2''$.
Collection Dr. and Mrs. Rudolf J. Heinemann,
New York City

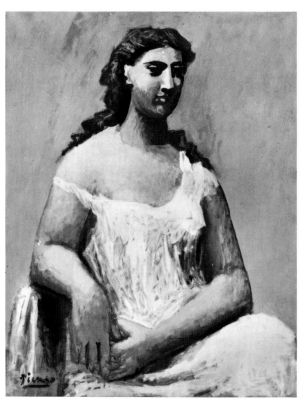

FIGURE 33. Picasso. *Femme Assise*. 1923.
Oil on canvas, $36^1/_4 \times 28^3/_4''$.
Tate Gallery, London

FIGURE 35. *L'Albanaise*. 1872.
Oil on canvas, $29^3/_8 \times 25^5/_8''$.
The Brooklyn Museum.
Gift of Mrs. Horace Havemeyer

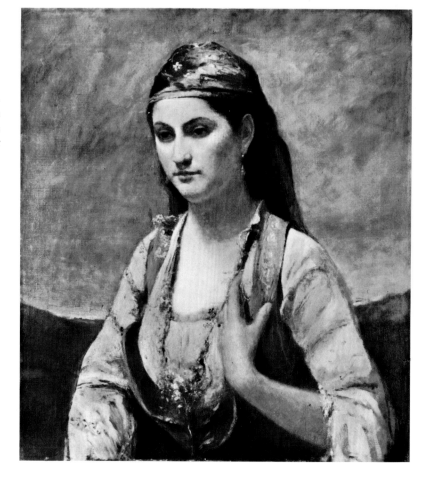

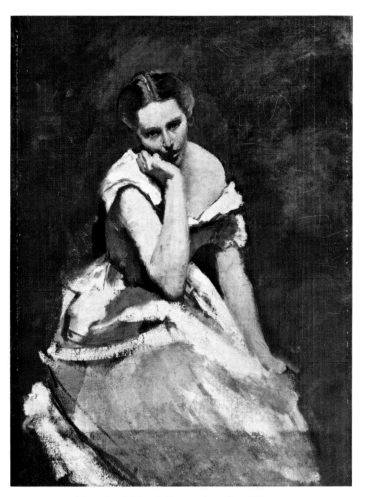

FIGURE 36. *La Mélancholie.* c. 1850–60. Oil on canvas, 20¹/₈ × 15". Ny Carlsberg Glyptothek, Copenhagen

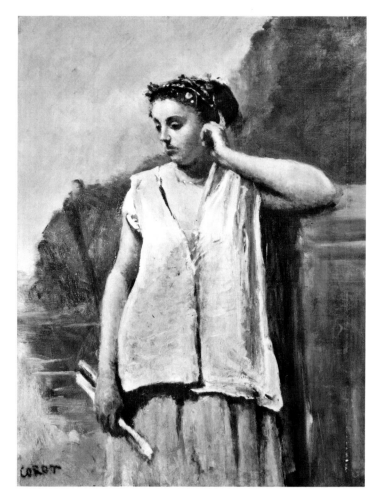

FIGURE 37. *The Muse—Comedy.* c. 1865. Oil on canvas, 18¹/₈ × 13⁷/₈". The Metropolitan Museum of Art, New York. Bequest of Mrs. H.O. Havemeyer, 1929. The H.O. Havemeyer Collection

Studio" (figs. 38–40). What we have here is a transposition of the musical and poetic themes that appear in the landscapes also executed in the studio from 1853 on. In the same building Corot maintained an apartment, in the drawing-room of which hung a canvas entitled *Woman with a Pearl* (colorplate p. 114). This large portrait is a symphony of grays. Radiographs have enabled us to see (fig. 41) how the artist poetically transformed the realistic portrait of the model first drawn on the canvas. When we compare the earlier stage in the construction of the face with a photograph of the finished portrait, we can see the changes of expression that occurred in the course of execution. In another canvas, the *Young Algerian Woman Lying on the Grass* (colorplate p. 120), the successive changes made by the artist can be followed even more clearly. Radiographs show (fig. 42) the young woman with her left knee raised and bent,

while in the final version both legs are stretched out. Such discoveries, though not necessarily of great significance in themselves, do throw light on the slow labor of artistic creation.

Study of the medium, of the materials used, can also be highly instructive. Corot was fond of small formats, particularly when he made studies from nature, sometimes using a rectangular canvas, sometimes wooden panels such as *Peasant Woman in a Landscape* (fig. 44) or the horizontal *River with Fishermen* (fig. 45), which must be one of the tiniest studies from nature ever made. There is nothing small about its subject, however, which seems to have been treated in a broader manner than the large composition entitled *Diana's Bath* (fig. 28), a work measuring 66¹/₈ × 101¹/₈". Paintings on cardboard are frequent, especially among the works executed and remaining in Switzerland. We also find cardboard or paper

36

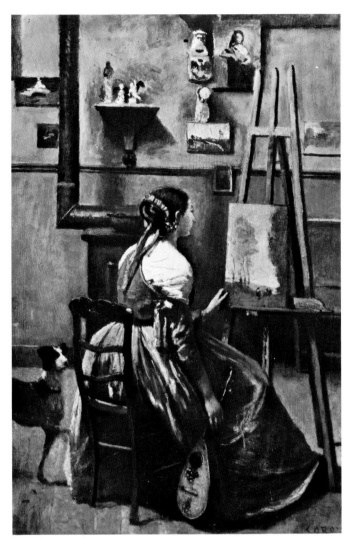

FIGURE 38. *The Artist's Studio.* c. 1860–70.
Oil on panel, 24³/₈ × 15³/₄″. The National Gallery of Art,
Washington, D.C. Widener Collection

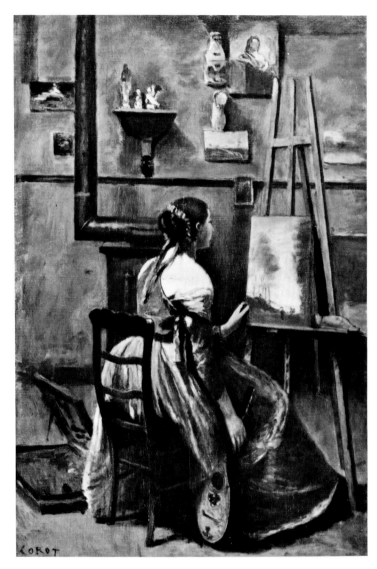

FIGURE 39. *The Artist's Studio.* 1865–68. Oil on canvas,
24³/₈ × 16¹/₈″. The Louvre, Paris

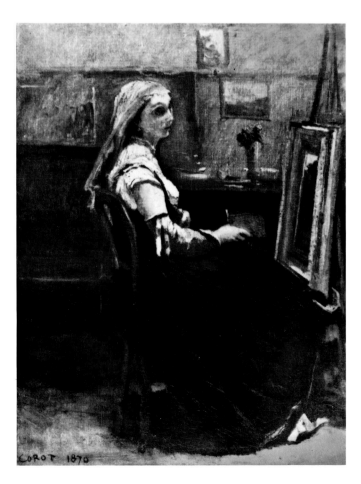

FIGURE 40. *The Artist's Studio.* 1870. Oil on canvas, 25 × 18⁷/₈″.
Musée des Beaux-Arts, Lyons

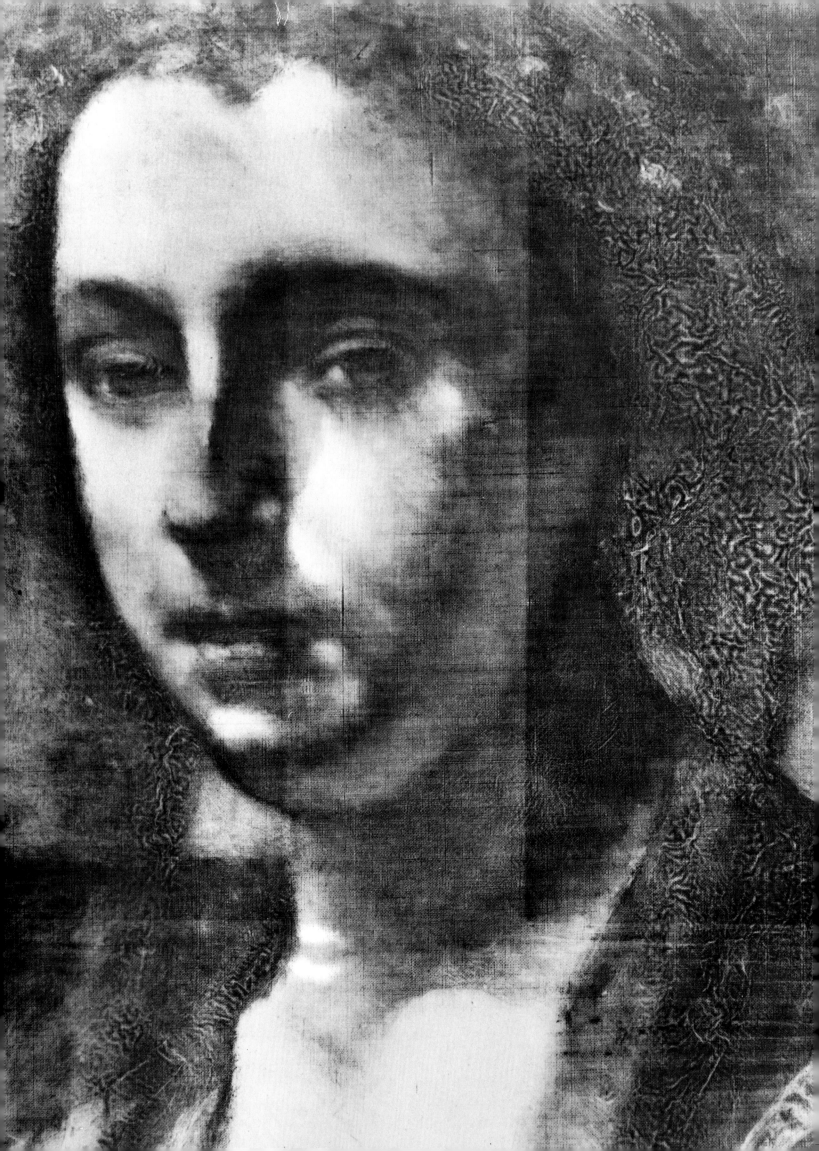

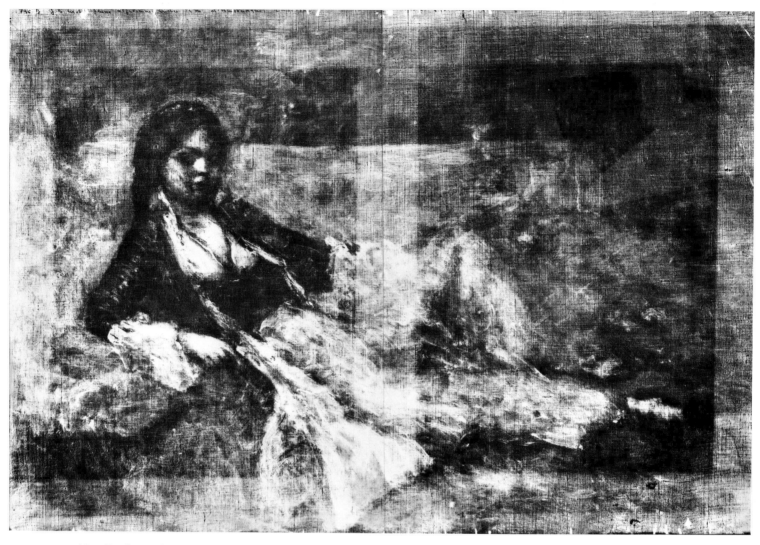

FIGURE 42. Radiograph of *Young Algerian Woman Lying on the Grass*

FIGURE 43. Delacroix. *Women of Algiers*. 1834. Oil on canvas, 70½×90½″. The Louvre, Paris

◀

FIGURE 41. Radiograph of *Woman with a Pearl*

FIGURE 44. *Peasant Woman in a Landscape.* Undated. Oil on wood, 16½ × 11¾″. Musée du Petit Palais, Geneva

mounted on canvas—*La Marietta* (colorplate p. 68) is a good example, and notable for the quality of its execution.

Corot employed a richly varied palette throughout his life. When working in the studio, he used comparatively few colors, but he mixed these to obtain an infinite variety of tones. One of his palettes was broken during a visit to Arras. Moreau-Nélaton gives us a description of it, especially interesting for the list of colors—nineteen in all.

Like his engravings; Corot's drawings are exercises, studies more often running parallel with rather than preliminary to his paintings, the point of departure for the latter being sought in small sketches from nature. It is clear today that among the studio works are a great many repetitions, varying only in

small details. *Recollection of Mortefontaine* (colorplate p. 100) is closely related, in arrangement and poetic feeling, to *The Boatman of Mortefontaine* (colorplate p. 102). The ponds of Ville-d'Avray—so familiar to Corot, who to the end of his life frequently stayed there, in the family house which he shared with his sister—are the leitmotiv of more than twenty poetic landscapes. Corot's persistence in rendering the variations in light, weather, and time of day at the same place foreshadows the researches of the Impressionists. Claude Monet was to do the same when he painted eighteen canvases of the facade of the Rouen Cathedral, recording all the variations in color from dawn to sunset.

Old Age and Fame

Fame came to Corot with the onset of old age, mitigating whatever discomforts the latter may have entailed. In the course of his long life, Corot met with much affection but little understanding on the part of his family, and he had been mortified by the fact that his painting evoked little or no response on the part of the public. He was nearly sixty before he could support himself by his painting. Then suddenly, beginning about 1855, commissions began to pour in, old friends were proud to say that they had known him for years, and new friends arrived in droves. Such fellow artists as Daubigny and Dau-

FIGURE 45. *River with Fishermen.* Undated. Oil on wood, 4¾ × 9½″. Private collection

mier, appreciating his generosity and modesty in the face of a growing reputation, showed great esteem for him, while many lesser artists, boasting of being his pupils, besieged his studio in the Rue Paradis Poissonnière in search of advice or encouragement, and, more often, financial help or small favors—crumbs from the tables of the famous—free use of his model, a theater or concert ticket, a letter of introduction to a picture dealer.

The constant comings and goings of such petitioners, models, friends, disciples, and tradesmen brought life and animation to the studio, where the master, calm, smiling, and cheerful, his pipe in his mouth, worked throughout it all, readily opening his heart and his purse. At the Salon, Pissarro was presented as a "pupil of Corot," and in fact when he arrived in Paris in 1855 the first thing he did was to call on the older artist. The latter counseled him to study nature and be true to it, and to concern himself with values. Corot's talent was too individual, and he was too involved with his own artistic experiment to be a teacher. Mostly he gave advice, as to Pissarro, but in Berthe Morisot's case he actually gave a few lessons, and after asking her to copy one of his paintings, he took her to Ville-d'Avray to encourage her to work from nature. His influence is particularly obvious in her *Thatched Cottages* (fig. 46), but she emancipated herself from his influence on meeting Manet. And let us not forget that Renoir passionately admired the aged Corot, whose *Lady in Blue* (colorplate p. 126) had an indisputable influence on him. Renoir was not so fond, however, of the people around Corot, and remarked openly, "I like Corot, but from a distance."

An anecdote quoted by François Fosca casts light on the attitude of the Impressionists toward Corot. In 1897, when Monet was nearly sixty, he visited a collection of paintings where he met the great connoisseur Raymond Koechlin. The latter said how delighted he was to see so many works of the Impressionist masters gathered together. Monet replied: "There's only one master here—Corot. Compared

FIGURE 46. Morisot. *Thatched Cottages* (*Chaumière en Normandie*). 1865. Oil on canvas, 18¹/₈ × 21⁵/₈". Private collection

FIGURE 47. Marquet. *The Port of La Rochelle*. 1920. Oil on canvas, 25⁵/₈ × 31⁷/₈". Musée des Beaux-Arts, Algiers

to him, the rest of us are nothing." And he added dejectedly, "This is the saddest day of my life." Although there was some exaggeration in these remarks, it is obvious that Sisley, for one, never freed himself from Corot's influence, that Monet, Renoir, Pissarro, and Berthe Morisot recognized Corot's supremacy in the art of rendering outdoor light, that Degas and Renoir, and latter Picasso, were directly or indirectly influenced by Corot's large figure paintings. Today it is clear that Marquet is in the direct line of descent from Corot no less than Boudin, and that Utrillo was following in Corot's footsteps when he as patiently applied himself to rendering the closely related values which subtly differentiate one gray wall from another. The painting of the later nineteenth century and of our own time is full of Corot's influence. This is not to mention those who imitated, copied, or plagiarized him. Few great painters have had to wait so long for public recognition as Corot did, nor, when fame finally came, has it often shown itself so blind, devouring, and indiscriminating. From 1865 on, forgers turned out incredible quantities of bad paintings in imitation of Corot's exquisite landscapes, his name on them being sufficient to ensure their sale. Germain Bazin has authoritatively treated this complex matter of the fake Corots. The artist's colleagues and friends—men like Caruelle d'Aligny, Marilhat, Daubigny, Dutilleux and Poirot—copied him in good faith, and works by such as these were later transformed into Corots by the addition of apocryphal signatures or seals. Bazin dissociates them from the line of dishonest profiteers, unscrupulous painters who—occasionally with Corot's indulgent complicity—executed hundreds of landscapes with nymphs dancing among the trees or daydreaming by misty woodland ponds, the mist not thick enough, however, to conceal the poverty of the palette and the flabbiness of the drawing. Corot had only contempt for the indiscriminate vogue for his work, though it benefited him materially. He realized that he was no less misunderstood now than he

had been before he was famous, and he continued to devote himself to outdoor painting during the many trips that he took each year despite his age. He painted the *Bridge at Mantes* in 1868 or 1869. No forger will ever attempt to copy or transpose this difficult subject, in which a meditative poetry and a keen sense of reality are inextricably wedded. About the same time, he captured with the same felicity the fleeting and violent aspects of nature, as in *Windswept Landscape* (colorplate p. 106).

Although Constant Dutilleux died in 1865, Corot continued to pay visits to Arras and Douai, where his friend's widow, children, and their families lived —including Alfred Robaut, his future biographer. It was here, in 1871, that Corot took refuge after the painful French defeat at Sedan and the Paris Commune. In 1871, he executed one of his finest works, *The Belfry of Douai* (colorplate p. 116), in twenty sessions. Despite his seventy-five years, Corot resumed his trips to various parts of France, to find that his fame now preceded him wherever he went. In 1872, he visited Arras, Rouen, Yport, many places around Paris, then Bordeaux, the department of Les Landes, and Coubron, where he decided to set up a studio in the country, a plan he carried out the following year. Such an act implies a confidence in the future quite remarkable at his age.

Interior of Sens Cathedral (colorplate p. 124) is a painting suffused by a soft golden light, and is somewhat reminiscent of the earlier *Chartres Cathedral* (colorplate p. 52). The work is dated 1874, and was executed in September, in three sessions, shortly before Corot returned to Ville-d'Avray to the bedside of his dying sister, Mme Sennegon. He was not to recover from this loss. Himself sick with cancer of the stomach, he went back to his studio in the Rue Paradis Poissonnière, and despite his illness worked steadily to prepare for the Salon at the time when the first Impressionist exhibition was being held in Paris. He was quite unaware of how much he had done to make Impressionism possible, although ten years earlier Constant Dutilleux had written: "Corot

FIGURE 48. *Ville-d'Avray*. 1865–70. Oil on canvas, $19^3/_8 \times 25^5/_8''$.
The National Gallery of Art, Washington, D.C. Gift of Count Cecil Pecci-Blunt, 1955

is the father of modern landscape. There is no landscape painter who is not indebted to him. I have never seen a picture by Corot that was not beautiful, nor a line that was not significant. Among modern painters Corot is the one who, as a colorist, has most in common with Rembrandt. The scale is golden in the one and gray in the other, but both employ the same means to attain the light and bring out one tone by juxtaposition with another" (Article on Constant Dutilleux by C. Le Gentil, Arras, 1876).

Corot died on February 22, 1875. His condition had begun to worsen on January 6; on January 29, he said to his bedside companion, Alfred Robaut: "You have no idea what new things I realize I can do. I glimpse things I have never seen before. It seems to me now I never knew how to paint a sky. What I see before me now is much more rose-colored, deeper, more transparent. Ah! how I'd like to show you these endless expanses of sky. . . ." Thus spoke the man who had just opened the doors to Impressionism, and of whom Delacroix said: "He is a rare genius and the father of modern landscape."

FIGURE 49. *Interior of Sens Cathedral* (detail). 1874. The Louvre, Paris

"*Le dessin est la confidence de l'artiste*" ("Drawing is the artist's intimate side"), Corot once wrote, and this is why it is so interesting to turn to the nearly one thousand sheets of his drawings, today scattered throughout the world, from small sketchbooks whose many-colored pages are covered with notes and working sketches. Reticent as he always was, Corot here becomes more accessible. Once he observed: "To my mind the two things of most importance are to make a concentrated study of the drawing and the values," and he mentions his resolution "to draw every evening." We know that he did so, and that his studio was littered with sheets of drawing paper, often crumpled and discarded, covered with smudged charcoal sketches, a considerable number of which have nevertheless been preserved thanks to Alfred Robaut and Etienne Moreau-Nélaton. Such as they are, Corot's drawings and engravings represent an important part of his *oeuvre*, more often running parallel to his painting than serving as preliminary studies. To the artist they provided ways of grasping reality, and these ways vary with the place, the subject, and the artist's state of mind. On paper he allowed himself more freedom to experiment, taking liberties he never took on canvas or panels.

He employed a wide variety of mediums. In the earlier part of his life, until around 1850, he used combinations of black pencil, red chalk, gouache (for highlights), and pen and ink, all on variously colored paper—gray, blue, pale yellow. Pink or white paper allowed him to carry out certain effects or experiments, which appear less developed in the sketchbooks, where street and theater scenes predominate.

From his first two trips to Italy, one recalls most easily the studies, precise as botanical plates, executed at Civita Castellana. We feel his self-discipline, the firmness of line, that would one day make him an excellent engraver. But we should not overlook those drawings in which his concern for composition, a linear definition of the landscape, are accentuated by touches of gouache, nor the bare, exact sketches accompanied by handwritten notes, numbered notations for later reference in the studio to indicate the relative values of sky, earth, and vegetation, to him of primary importance. Even certain studio drawings bear numbered marks; they show that in his figures Corot took equal care in rendering values.

This precise technique, the fruit of his classical studies in France and Italy, and as sharp as Ingres' (see, for example, *Mon Agaar*, fig. 50), was gradually to give way to a more flexible manner, with greater attention to shading, which corresponds to his experiments in rendering light. To convey the suppleness of leafy branches trembling in the silvery light of the Ile-de-France or in the mists of the English Channel, which he often visited beginning in 1853, he was to use charcoal, a technique new to him. From time to time, he obtains poetic effects without equal, as in *The Bed*, a charcoal composition on pink paper, or *Recollection of Mortefontaine*.

The mastery that comes with old age encouraged Corot to try new techniques. The desire to free himself occasionally from his perpetual studies of

nature, to express his inner visions, led him to engraving. It was his friend Constant Dutilleux, a lithographer, who drew the master's attention to a new process that he had discovered around 1853—*cliché-verre*. This process seemed to make it possible to combine photography and lithography. A plate of glass was first coated with printer's ink by means of a lithographic roller, and then sprinkled with talc to hasten drying. The artist then drew on it with an engraver's needle. This operation completed, a sheet of sensitive paper was applied and the plate exposed to sunlight.

This technique scarcely allowed for more than two or three proofs, but from the outset Corot's were remarkable, though less so than the etchings and lithographs he executed toward the end of his life. The etchings are few in number, but no one has gone further in mastery of this art, thanks to the constant search for correct values by which Corot was guided in all aspects of his work.

Only Paul Valéry has been able to do justice to Corot's graphic *oeuvre* in words: "With such abstract means—pen, pencil, engraver's needle—Corot achieves marvels of light and space: never have trees been more vivid, clouds more shifting, horizons broader, nor the earth more solid than in these few lines on paper. Leafing through these astonishing pages, we feel that this man lived in the sight of natural things as a contemplative man lives within his thought."

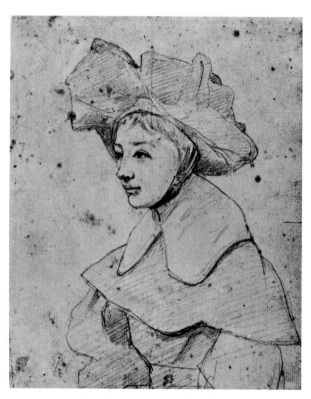

FIGURE 50. *Mon Agaar.* c. 1840. Pencil on white paper, 7¼×6″.
Cabinet des Dessins, The Louvre, Paris

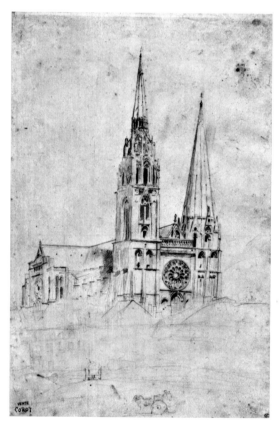

FIGURE 51. *Chartres Cathedral.* 1830. Pencil on white paper, 10⅞ × 7¼″.
Cabinet des Dessins, The Louvre, Paris

COLORPLATES

THE FORUM SEEN FROM
THE FARNESE GARDENS

Oil on paper mounted on canvas, $11 \times 19^5/_8''$

The Louvre, Paris

This painting was executed from nature in May, 1826, during Corot's first trip to Italy. A masterpiece, it marks the transition from the classical landscape as represented in France by Poussin and Claude Lorrain (a canvas on the same subject by the latter is shown in fig. 9) to the modern landscape as later conceived by the Impressionists. Though for a short time a pupil of Michallon, also a disciple of Valenciennes and Bertin, both of whom followed the tradition of the Neoclassical landscape, Corot was above all an independent artist. Born in the eighteenth century, he was educated at Rouen by eighteenth-century teachers who, imbued with the principles of Jean-Jacques Rousseau, instilled in him a deep love of nature. It was during his first visit to Italy that he discovered how to combine naturalness with a classical conception of composition.

This picture was painted on the Palatine Hill, as were two others: *The Colosseum Seen from the Farnese Gardens* (fig. 10) and *View from the Farnese Gardens, Rome* (fig. 11).

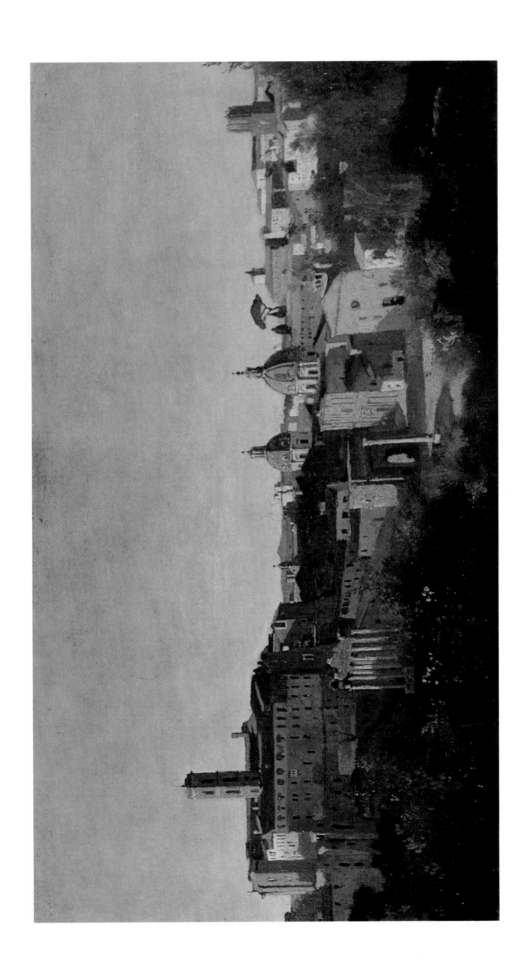

LE PONT DE NARNI

Oil on canvas, 28 × 38"

National Gallery of Canada, Ottawa

The bridge built by the Emperor Augustus over the Nera was the object of a study executed on the spot by Corot in 1826 during his first visit to Italy. He was filled with surprise and wonder at this vast, wild landscape, so different from the well-ordered scenery of the Ile-de-France. The study done from nature (*The Bridge at Narni*, fig. 12) exhibits bold, sweeping brushstrokes. It is interesting to compare it with this studio composition in the National Gallery of Canada.

Corot displays a detachment in the face of nature, an objectivity that anticipates Cézanne and the modern landscape. In this large composition, deliberately transformed into a pastoral scene, the artist harks back to his former masters, to Claude Lorrain and the French painters of the eighteenth century; there is a suggestion of Fragonard and the Neoclassical landscapists.

For all its harmony, we discern in this work the young painter's uncertainty, not so much in the execution, which is admirable, as in his concern to relate himself to the masters of the historical landscape. This concern was to recur throughout his life, and we can follow the stages by which he was led in his mature period to transmute the realistic landscape into a great poetic composition on the theme of recollection.

Despite the breadth of this composition there are no breaks or gaps— foreground and background are joined by the uniform thinness of the pigment. Corot's genius makes us perceive the pliancy of the grass, and beyond it the hardness of the earth. Cézanne seems to have known and studied this canvas.

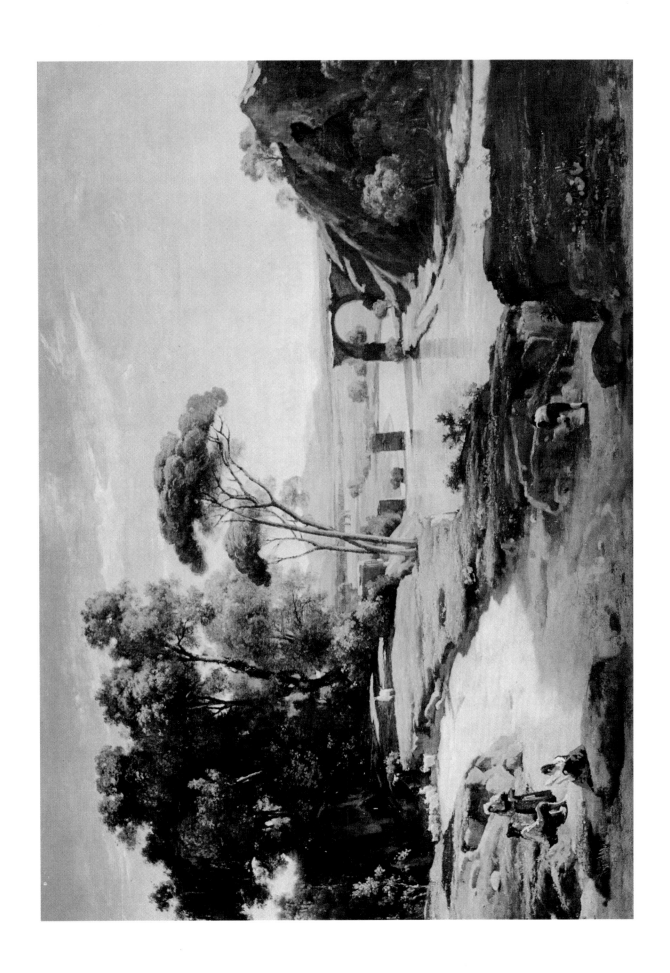

CHARTRES CATHEDRAL

Oil on canvas, $25^5/_8 \times 19^5/_8$"

The Louvre, Paris. Collection Moreau-Nélaton

Nothing could be cleaner, firmer, more light-drenched than this picture, which Corot painted after returning from his first trip to Italy. After a short stay with his family, to whom he was always much attached, Corot fled Paris during the Revolution of 1830. He stopped at Chartres, where he made some very accurate drawings of the cathedral —a view of the north portal, of which one oil study is extant, and a preliminary drawing for the canvas shown here. The drawing (fig. 51) is extremely tight and detailed.

Corot kept this painting in his studio until almost the end of his life, and around 1872 gave it to Robaut. About the same time he added the figure on the left and altered the one on the right. These corrections were known to Robaut, and are confirmed by radiographs which in addition make possible a better appreciation of Corot's manner. His superb talent for layout is already well developed in this canvas: the foreground is stripped bare in order to focus interest on the background, thus giving the painting great depth, and the cathedral its own volume in space. The brushwork is still fairly thin and smooth, with no hint of the bright impastos he was to employ shortly thereafter.

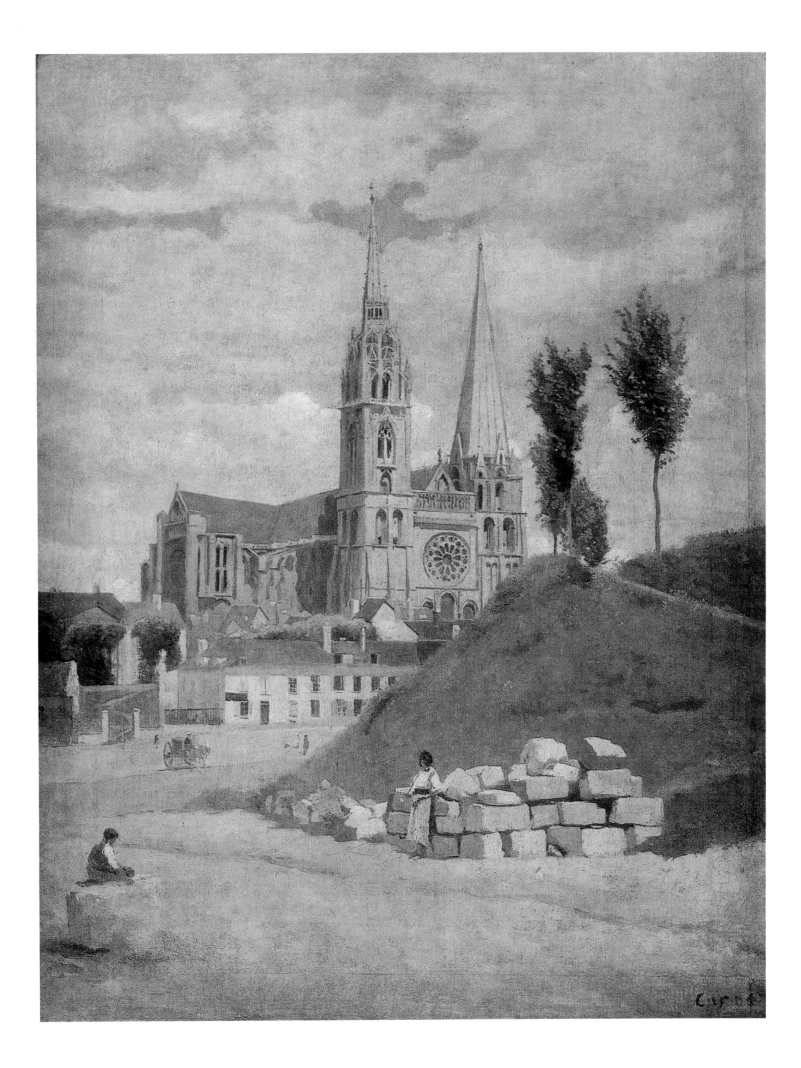

MLLE ALEXINA LEDOUX

Oil on canvas, $14^1/_8 \times 10^5/_8$"

The Louvre, Paris

This portrait was painted about 1830, after Corot's first trip to Italy. If we compare it to the self-portrait of 1825, we can see the artist's progress, the mastery acquired through contact with Italy. However, the brushwork here is still thin and rather constricted: one dark line with the brush outlines the face. There is a certain stiffness here, a certain reticence, which is perhaps to be explained by the model's personality and her relations with the artist.

Alexina was one of Mme Corot's seamstresses. It seems that she was strongly attracted to Corot, and he was by no means indifferent to her. During his four-year stay in Italy he wrote regularly to his friend Abel Osmond, to whom he confided his feelings about Mlle Alexina. He may even have planned to marry her, but painting is an exacting mistress, and Corot remained a bachelor. Nor did Alexina marry—she retired to Poitiers with her nephew Abel Chambaud, of whom Corot made an excellent portrait in schoolboy uniform (The Louvre).

Alexina died at the age of fifty. With customary reticence Corot reports his last meeting with her: "The girls employed by my mother were eager to see M. Camille in his new state as a 'painter' and often left the shop to come and watch me. One of them came more frequently than her companions. She is still living, she has not married, and comes to see me from time to time. She was here last week. O my friends, what a change, and what reflections it brings up. My painting has not budged, it shows the hour and the time of day I made it, but Mlle Rose and myself? What has become of us!"

Note that for discretion Corot refers to Alexina as Mlle Rose when speaking to his friends.

In this relatively early painting, Corot is already in control of his canvas. The figure is well placed, and the economy of means, the thickness of the pigment, and the pyramidal composition are all his own.

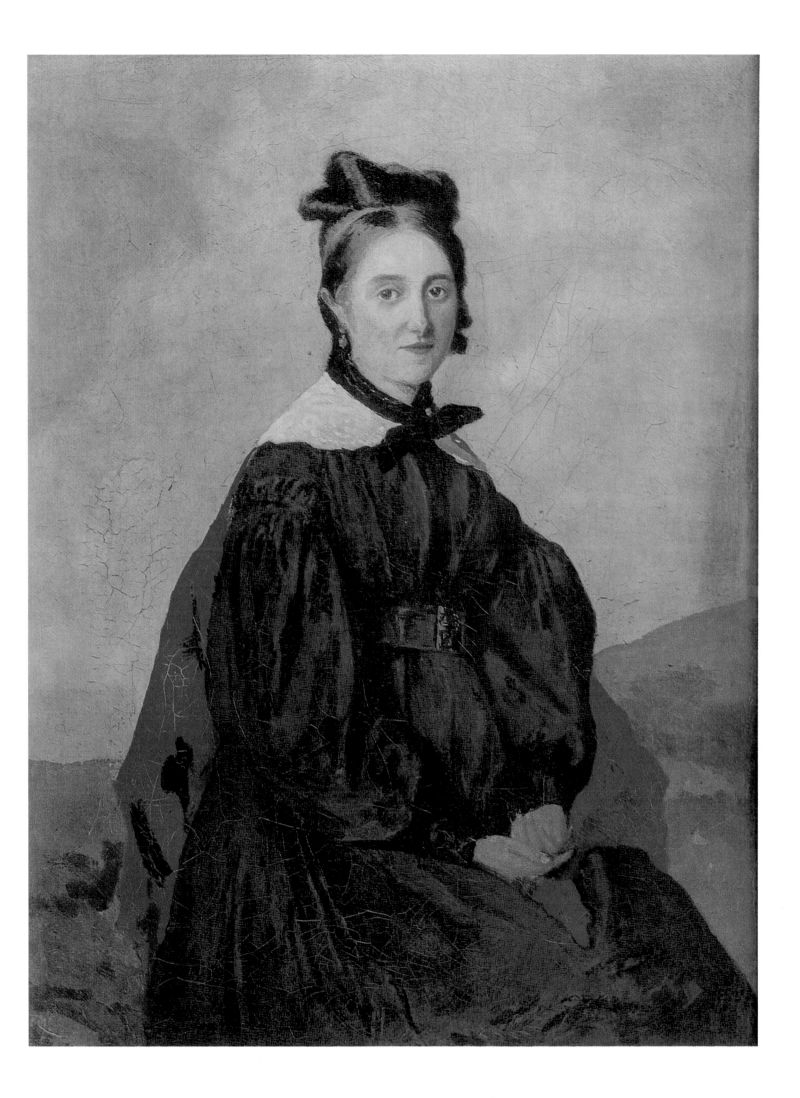

LA CERVARA

Oil on canvas, 26 ³/₄ × 37 ³/₈"

Kunsthaus, Zurich

The signature at the lower right is later than the painting itself: Corot added it at the request of Georges Lemaistre, the second owner. The painting was executed in the studio, in 1830, after the artist's long sojourn in the Roman countryside, where between 1826 and 1828 he made a large number of studies.

By its rather somber color, its dramatic distribution of light and shadow, it brings to mind certain romantic compositions by Delacroix. It must be remembered, however, that Corot was rarely influenced by the literary and aesthetic attitudes of Romanticism. Instead there would seem to be a classical influence that consciously or unconsciously led him to express a feeling of man's insecurity in the face of nature. The struggle of man against the elements goes back to Poussin, whose painting entitled *Winter* (*The Deluge*, fig. 8) is the most dramatic example.

La Cervara belonged to Corot's mother. This vast and noble composition in the classical tradition must have aroused a certain interest in the rather conventional *belle dame*. We know that she frowned on her son's careless attire and free and easy ways, but we also know that she saw him daily, and that theirs was a most affectionate relationship.

The broad and skillful style of this work recalls other compositions, like those of the Roman Campagna and the *Cervara* in The Louvre (1827), done after the Narni paintings of 1826.

Painted in 1830

THE PONT-AU-CHANGE AND
THE PALAIS DE JUSTICE

Oil on canvas, 19⁵/₈ × 28³/₈″

Private collection, New York

This subject had been familiar to Corot since childhood. We know that after his adolescence he took walks along the banks of the Seine almost every day, and some of his earliest sketches were of such scenes. Moreover, beginning in 1817 he attended evening classes at the Académie Suisse, which was located on the Quai des Orfèvres. Robaut lists several works painted by Corot in the heart of Paris. Among them is the *Pont-au-Change,* which was exhibited in the United States at the Philadelphia Museum of Art in 1946.

The peaceful atmosphere and the artist's objectivity are here specially noteworthy. Boudin, Lépine, and later Marquet are all heirs to Corot, who here renders the charm of Paris as it was then and still is today—the expanse of sky full of nuances, gray and soft, harmonizes and fuses, so to speak, with the buildings below. As Germain Bazin remarks, the composition and the figures are reminiscent of the picturesque "views" fashionable at the beginning of the century and during the Romantic period.

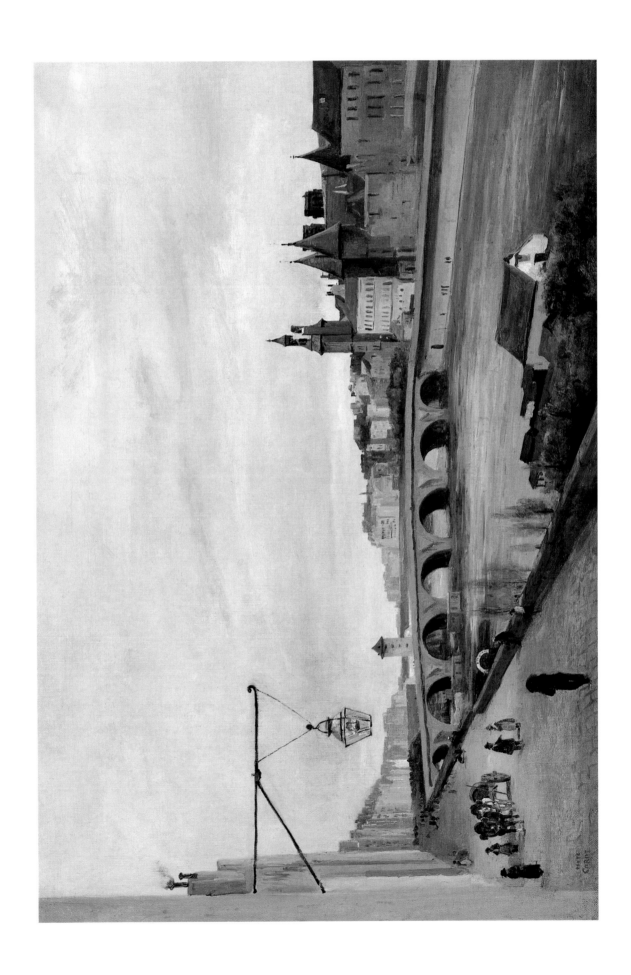

VIEW OF GENOA FROM
THE PROMENADE OF ACQUA SOLA

Oil on canvas, 11 3/4 × 16 1/8"

The Art Institute of Chicago

Corot executed this painting in the spring of 1834, during his second trip to Italy, made in the company of the painter Grandjean. He traveled by way of Lyons and Marseilles, then along the Mediterranean coast, arriving in Genoa in June, where he stayed briefly before going on to Pisa and Florence. In Genoa he painted three pictures, numbered 300, 301, and 302 in Robaut's catalogue. This is No. 301.

Here we have one of Corot's most luminous works: the city seems consumed by light, surrounded by the opulent vegetation in the foreground and the sea in the background, and with the implacable sky giving the composition its unity.

The rich colors of the vegetation are rendered with animated, forceful brushstrokes, especially perceptible in the left foreground. The movement that enlivens the pigment and effectively renders the vibrations of the air under a melting sky is exceptional in Corot's *oeuvre*. Many years later, Van Gogh was to react similarly, though with even greater vehemence, to the Mediterranean light.

Corot's mastery and his taste for lucidity of design are exemplified in both this composition and in *Venice: The Grand Canal Seen from the Campo della Carità* (private collection, Paris), which he executed in Venice a few weeks later.

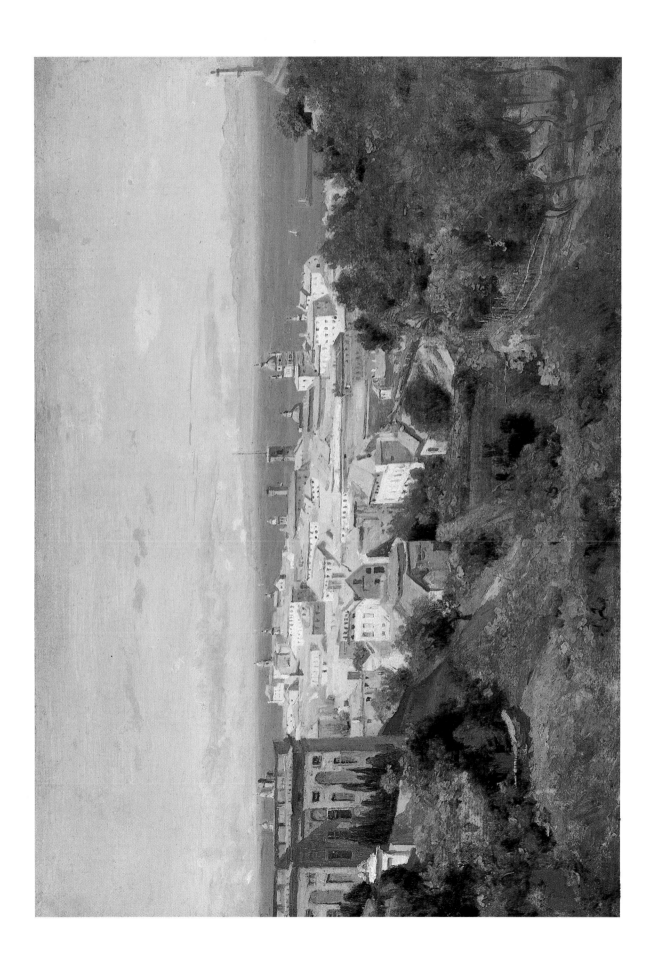

SELF-PORTRAIT WITH PALETTE

Oil on canvas, $13^3/_8 \times 9^7/_8$"

Uffizi, Florence

By comparing this work painted about 1835 with the self-portrait of 1825, we can measure Corot's progress as a painter. In the ten years that have elapsed, Corot has achieved technical mastery and artistic maturity. Here he is nearly forty and in full possession of his powers. Everything in this work suggests self-assurance: the pose has a firmness that recalls the busts of Verrocchio; the economy of color and density of the pigment also suggest sculpture. Though the canvas is a small one, its monumental aspect is unmistakable; every detail holds up under enlargement and reveals the decisiveness of line. Never will the artist's style be firmer. The broad strokes have been made with a brush heavy with pigment. Corot's triumph here is in the tradition of French seventeenth-century painting, as he was to triumph many years later with another picture, the *Woman with a Pearl*, in an art made up entirely of subtleties of light and color.

A comparison of these two pictures confirms Dutilleux's judgment that the whole of nineteenth-century French painting is implicit in Corot's art.

To come back to this self-portrait, nothing in it suggests the easy-going "*bonhomme*" Corot, so touchingly described by Moreau-Nélaton. This is a man fully conscious of his dignity, but already marked by the rebuffs that would continue to be his fate until he was well past fifty.

It is instructive to compare this painting with photographs taken a few years later by Charles Desavary and Adolphe Grandguillaume. They show the same dignity of bearing, sobriety of expression, and hint of suffering in the features, and throw new light on the psychology of the artist.

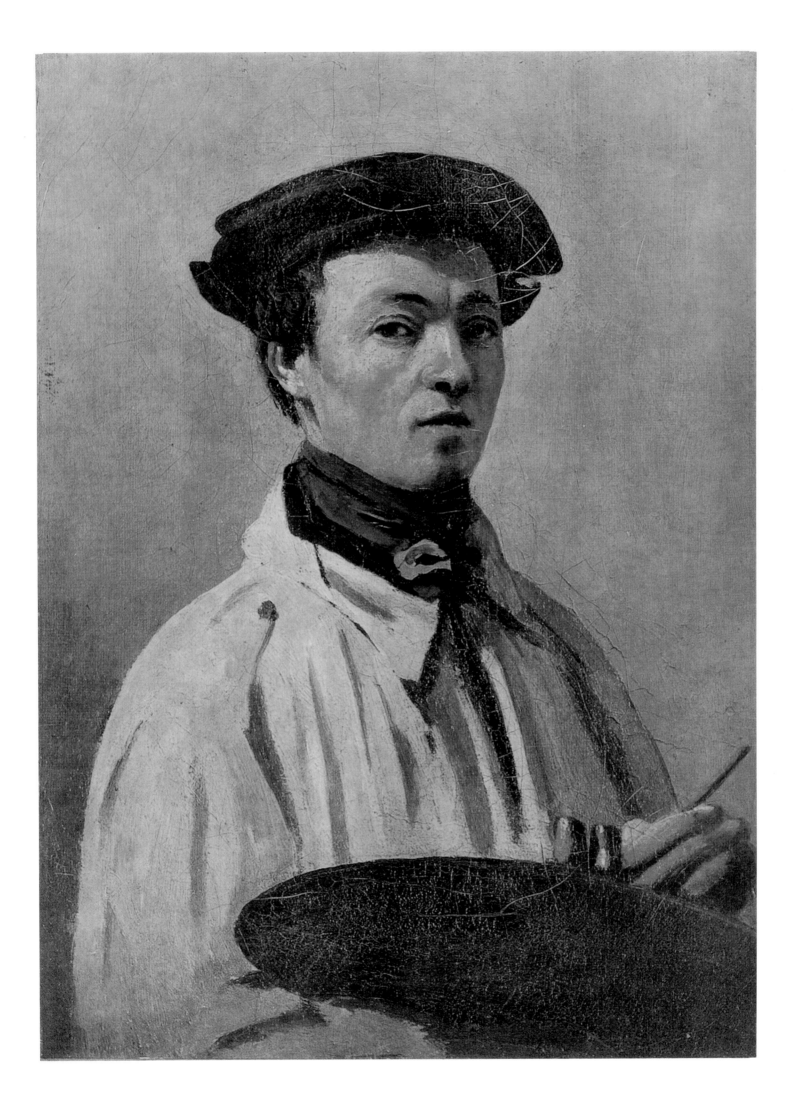

HAGAR IN THE WILDERNESS

Oil on canvas, 71 × 106 ¹/₂"

The Metropolitan Museum of Art, New York. Rogers Fund, 1938

On returning from his second trip to Italy, Corot was not only concerned to go on painting from nature, but also to utilize for his studio compositions the numerous views that he had brought back.

This picture was apparently composed in 1835, and enjoyed great success when exhibited at the Salon that same year. There is a preparatory sketch which seems to combine disparate elements: according to Germain Bazin, the trees derive from a study made at Fontainebleau, while the rocks are taken from a study executed at Castellana between 1826 and 1828, during the artist's first sojourn in Rome.

The completed work illustrates the passage in the Bible (Gen. 21: 14–21) which relates how Abraham banished Hagar and her young son Ishmael to the desert, and how an angel of the Lord appeared to her when she was dying of thirst. For his barren landscape under a torrid sun, Corot drew upon parts of Tuscany which he had just visited.

Charles Lenormant, one of the first critics of Corot's day to become interested in him, commented on this painting as follows: "Here the general view cannot be too monotonous nor too desolate. This landscape by M. Corot has something that grips you even before you become aware of the subject. This is the characteristic virtue of historical landscape, i.e., harmony between the site and the passion or suffering that the painter chooses to place there. . . . I find unpretentious simplicity here, a genuine naïveté in the way he has painted the angel soaring like a bird to Hagar's assistance."

Admirable mountains surmounted by a luminous sky serve as the background to this splendid scene.

Henceforth, Théophile Silvestre, Gustave Planche, and Théophile Gautier all had praise for Corot's talent. Five years later, for the church at Rosny-sur-Seine, he painted a *Flight into Egypt* which is similar in feeling to this work.

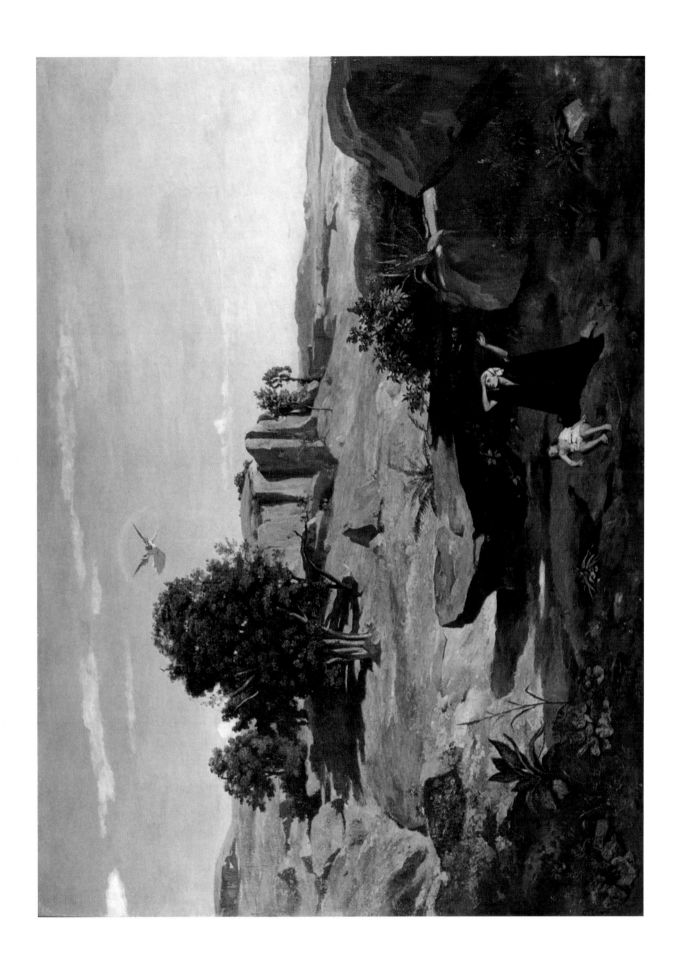

CHÂTEAU DE ROSNY

Oil on canvas, $9^1/_2 \times 13^3/_4$"

The Louvre, Paris

This pink-and-white château, a fine seventeenth-century structure, once belonged to the Duchesse de Berry. Corot visited it frequently after it was acquired by his boyhood friend Abel Osmond.

Corot signed this painting and dated it 1840. He gave it to Mme Osmond, who bequeathed it to her nephew Louis Robert, a magistrate at Mantes, who was also a close friend of Corot's. The work, enchanting with its graceful light and its skillful, slightly off-center arrangement, effectively renders the *plein-air* atmosphere. One feels the influence of Bonington, the English landscape painter who lived in France from 1818 until his death in 1828, and who was awarded a gold medal at the Salon of 1824. Bonington executed a charming watercolor of the same subject, now in the British Museum. It is certain that Corot was influenced by the early nineteenth-century English landscapists who did so much to liberate the art of landscape from the prevailing conventions.

Abel Osmond, the owner of the château, was Corot's closest confidant, and it was to him that the artist wrote his impressions, his enthusiasms, and his disappointments during the three years of his first trip to Italy. On March 10, 1827, he wrote: "I don't know whether it's lucky or not, but now and then my painting seems quite bad to me though some say I have made progress. I have only one piece of advice to give you: don't ever take up painting if you want to live in peace." Fortunately this sense of exasperation did not last. A fine portrait of Abel Osmond painted by Corot in 1829 is in the collection of Dr. Marjorie Lewisohn, New York (fig. 13).

Throughout his life Corot paid visits to Rosny and Mantes. He painted many landscapes from nature in and around Rosny, and some of these had a considerable influence on Sisley.

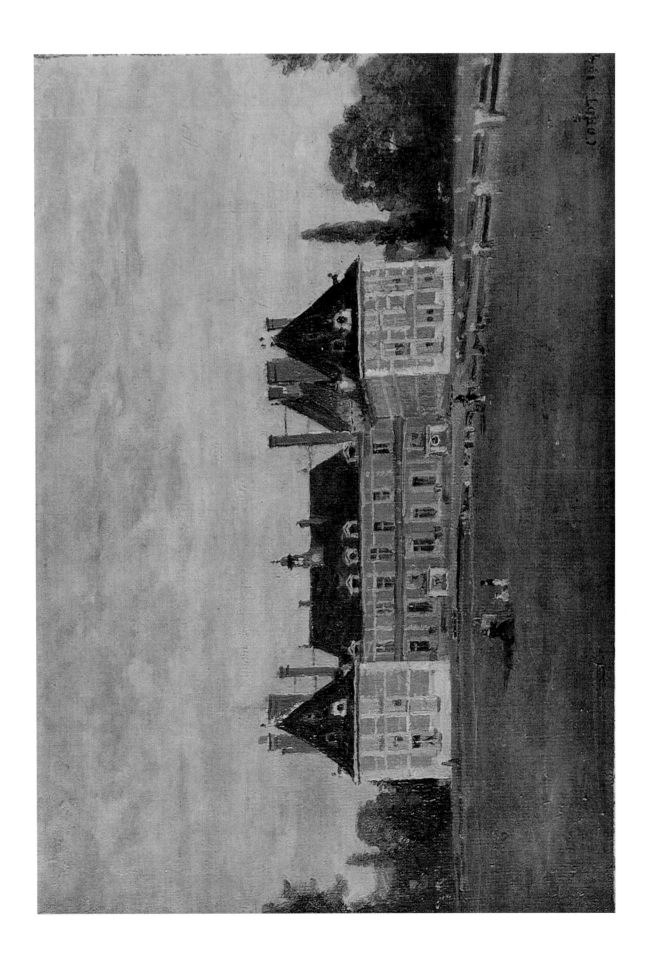

Painted in 1843

LA MARIETTA

Oil on paper mounted on canvas, $11^{3}/_{8} \times 16^{1}/_{2}''$

Musée du Petit Palais, Paris

Corot painted this masterpiece during his third and last trip to Italy. It was probably executed in the studio of one of his friends in Rome, the French painter Benouville. The model is a handsome girl whose name the artist included in an inscription at the top of the painting: *Marietta à Rome.*

The exceptionally smooth surface of the pigment is due to the fact that this is a study on paper which was later pasted on canvas; the oils were much thinned out and treated almost like watercolor. Infrared photography shows traces of black lead drawing under the very light glaze.

The perfection of line and elegance of feature suggest the Odalisques of Ingres. This painting is a demonstration of Corot's versatility.

A certain number of nude studies by Corot are to be found in the print rooms of museums—as a rule they are very academic. This composition is remarkable for combining perfection of line with a freedom and realism of expression not to be found again until Manet and, later, Cézanne.

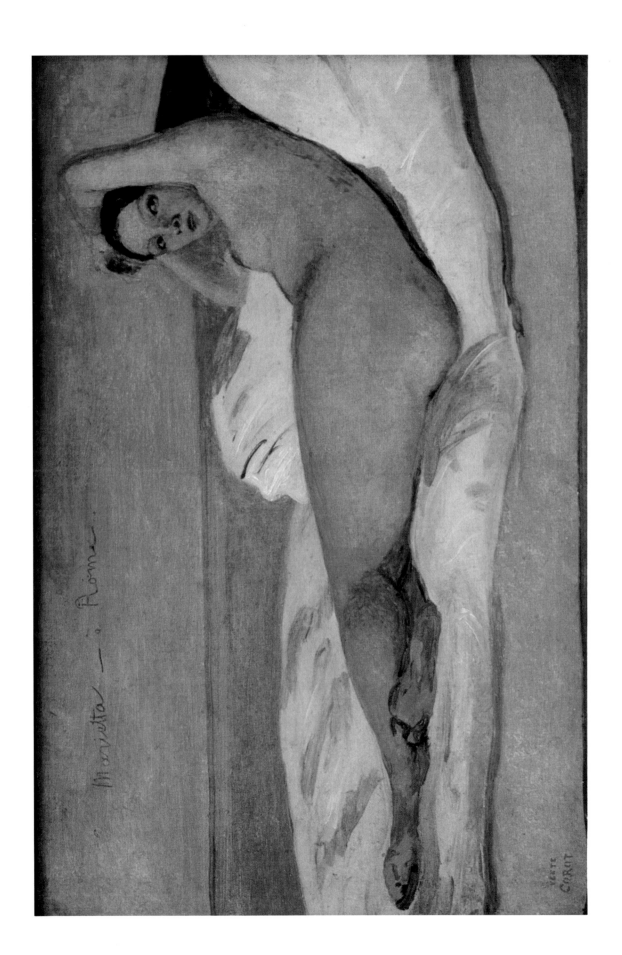

GARDENS OF THE VILLA D'ESTE AT TIVOLI

Oil on cardboard, 16 7/8 × 23 5/8"

The Louvre, Paris

This work was also painted during the third and last visit that Corot made to Italy, this time in the company of the painter Brizard. A masterpiece, it combines personal sensibility with great technical skill. Corot was surely conscious of his achievement when, some years later, he asked his pupil Berthe Morisot to make a copy of it. Before entering The Louvre, this canvas belonged to the Rouart family, and Degas, a frequent visitor to the house, was often seen to admire it.

The cypresses bathed in light frame the scene with unequalled naturalness and nobility; here one feels that Corot instinctively possessed an exceptionally strong sense of composition. The picture is composed like a seventeenth-century monument. The buildings rise in tiers in the still light. The noble outlines of the Sabine hills dominate the composition and emphasize the beauty of the landscape. The boy in the foreground—he had carried Corot's paintbox and easel—provides a human dimension which allows us to perceive not only the artist's matchless skill but also his creative response in the face of such beauty.

The serenity of evening in the ancient land of Italy, the limpidity of the Mediterranean sky, have never been rendered better than by Corot. This little painting makes us understand that the genius of Corot is the real link between the classical landscapes of Claude Lorrain and the modern ones of Cézanne and the Impressionists.

Whether we approach him from the past or from the present, Corot's unaffected talent remains strikingly fresh.

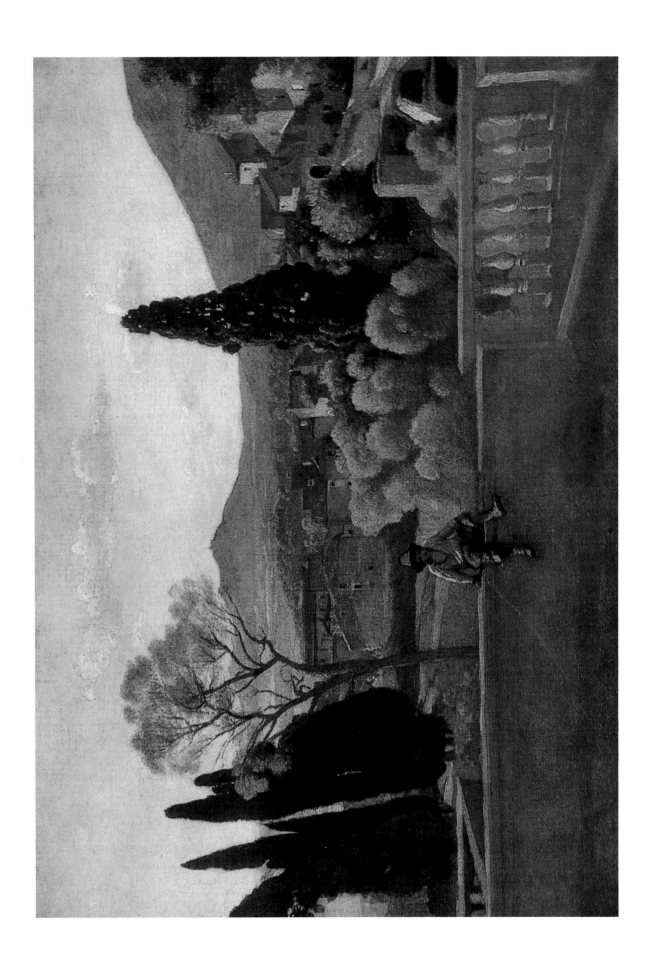

BELL-TOWER OF THE CHURCH
OF SAINT-PATERNE AT ORLÉANS

Oil on canvas, 11 × 15 ³/₄″

Musée des Beaux-Arts, Strasbourg

Corot did not discover Holland until 1854, in the course of a week's trip that he made there with his friend Constant Dutilleux. The latter tells us of Corot's admiration for Rembrandt but does not record his exposure to Vermeer. Yet in this little picture, painted in the 1840s in the heart of France on the banks of the Loire, Corot had discovered for himself something very like Vermeer's secret. It is so perfectly painted, the colors are so harmonious, and the composition so sure that *View of Delft* comes irresistibly to mind. This work, like Vermeer's, is timeless. It is as though wind, weather, and sunlight were suspended, and by some magic the grace of the morning light fixed forever by the artist's brush to testify to the beauty of creation.

Many paintings are more impressive, more stirring, but few are more seductive than this one. Here the subtlety of nature is set against the solidity, the density, of man's constructions. Never has this contrast been better rendered. Foreground and sky are harmoniously linked by the tower of Saint-Paterne, which seems a synthesis of the temporal and the spiritual.

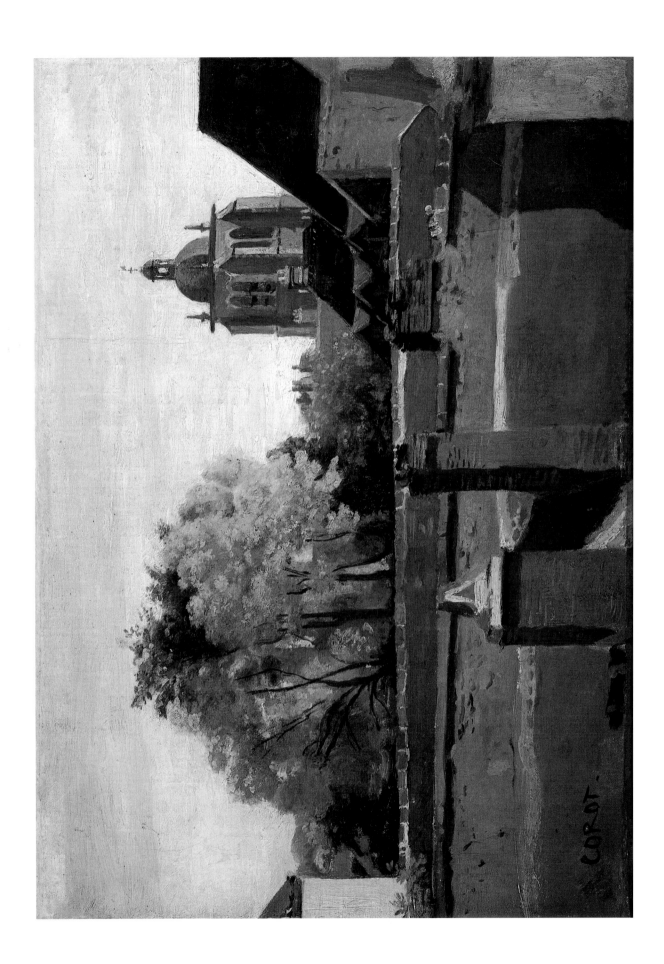

HOMER AND THE SHEPHERDS

Oil on canvas, 31¹/₂ × 45¹/₄″

Musée Municipal, Saint-Lô

This work was exhibited at the Salon of 1845. One of Corot's most famous historical paintings, its inspiration was a poem by André Chénier, who died under the guillotine in 1794. What unifies the painting is the light, still warm but fading, in which figures and trees alike are bathed. According to Jean Leymarie, Corot based the setting on sketches made near Royat in 1839. The two figures in togas in the background give the composition the desired depth; their noble silhouettes accord with the nonchalant poses of the three young shepherds in the foreground, who listen to Homer accompanying himself on the lyre. Homer's features are taken, scarcely disguised, from a figure by David.

Poussin and Claude Lorrain inspired Corot no less than Chénier. For Corot this painting marks a brilliant return to the Neoclassical tradition of his earliest teachers, Bertin and Michallon.

There is more than the poetry of Chénier and the tradition of the seventeenth-century landscapists behind this painting. All his life, Corot loved Vergil's *Eclogues,* which he carried with him on his journeys and lines of which he knew by heart. This painting is further proof that Corot was a man deeply imbued with the culture of the ancients as well as with a love of nature rising from a true paganism.

Critics praised this painting, which, despite the harmony of the composition, seems to us today filled with a rather literary bucolic sentiment. In 1859 Baudelaire wrote in reference to this work: "His [Corot's] harmony is infallibly rigorous, and he has a profound sense of construction. The color only seems too soft and the light crepuscular by contrast with the shrillness of the paintings around it."

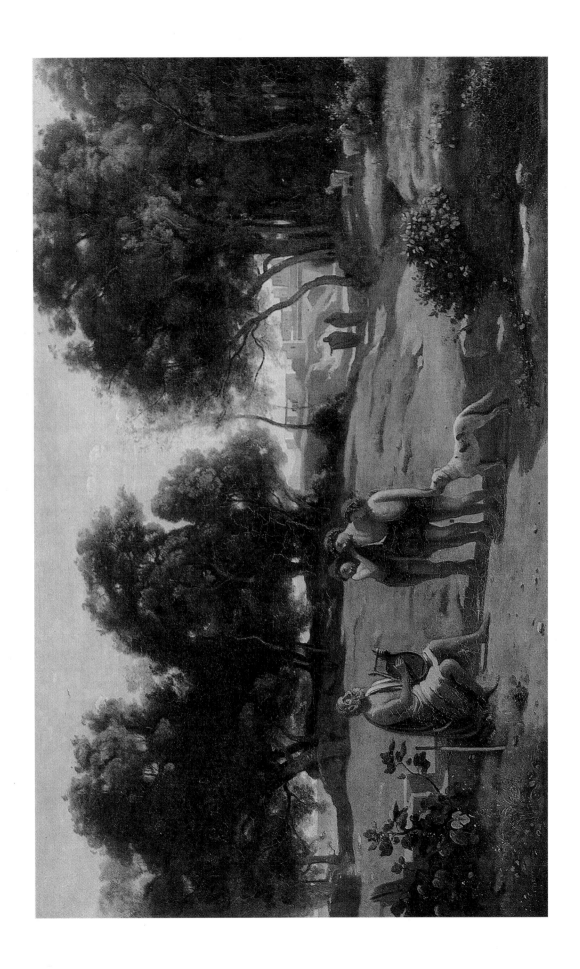

PORTRAIT OF MME CHARMOIS

Oil on canvas, 16¹/₂ × 13³/₈″

The Louvre, Paris

Claire Charmois, daughter of Corot's sister, Mme Sennegon, seems to have been the artist's favorite niece, the most charming and elegant of the young women of his circle, and the one who most resembled her grandmother, *"la belle dame* of the Quai Voltaire." It was thus that Corot used to refer to his mother, a fashionable milliner from whom he must have inherited his sense of color harmony and sureness of taste.

It would be hard to find a portrait that is better composed, or one that has greater simplicity while at the same time conveying effectively the sitter's elegance, modesty, and reserve.

The thickness of the paint, the beauty of the impasto employed for the light colors, are in the best French tradition. They recall the sureness of feature, the inner psychology, the economy of effect characteristic of such sixteenth-century French portrait painters as Clouet and Corneille de Lyon. The dense pigment here is like that of the Le Nain brothers in the seventeenth century, Chardin's in the eighteenth, and it will turn up again in Cézanne.

Executed about 1845, this work shows the master in full possession of his powers. For a long time the human figure served Corot principally as an index to the scale of his compositions. Little by little, however, he developed a taste for portraiture as he set down the features of friends and loved ones; he became more and more attached to the human figure, and from 1850 on, portraits assume increasing importance in his *oeuvre*, both in number and size. Not all of his portraits, however, display the concern for veracity, the concentration of interest on the face, the need to capture much more than the moment that make his figures of young women and children, painted in the years before 1855, marvels of psychological insight.

One of the descendants of Mme Charmois bequeathed this portrait to The Louvre in 1926, and in 1946 it was included in the special exhibition, *Masterpieces of The Louvre.*

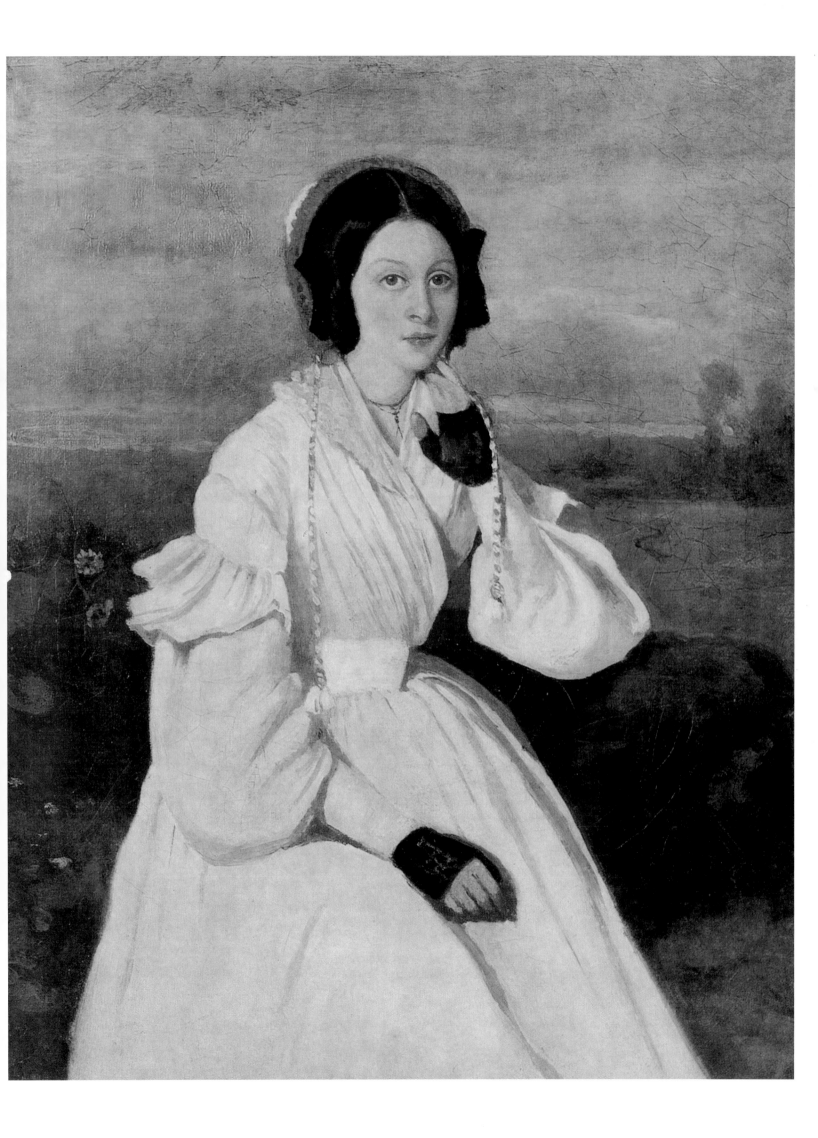

FOREST OF FONTAINEBLEAU

Oil on canvas, 35³/₄×51″

Museum of Fine Arts, Boston. Gift of Mrs. Samuel Dennis Warren

This painting was owned by Alfred Robaut, friend and biographer of Corot. It was painted during one of the many visits Corot made to the Forest of Fontainebleau in the 1830s and '40s. Exhibited at the Salon of 1846, it was received less enthusiastically than Corot's entries of the preceding year. However, Baudelaire wrote: "Unfortunately, all he has given us this year is one landscape, of cows drinking at a pond in the woods at Fontainebleau. M. Corot is not so much a colorist as a harmonist; always devoid of pedantry, his compositions fascinate by their very simplicity of color."

Gustave Planche wrote of this painting in the *Revue des deux mondes*: "M. Corot's work is interesting for the choice of setting and for its elegant sweep of line. . . . It is impossible to look at this composition without pleasure, for it reveals the independent temperament of its author."

Although people still had reservations about his work, Corot was beginning to win fame and recognition. It had taken until the age of fifty, and until now practically his only buyer had been the Duc d'Orléans, who purchased two paintings for the Galerie du Palais Royal. However, this same year, 1846, Corot was awarded the cross of the Legion of Honor, to the great surprise of his family, particularly his father, who had scant appreciation of his son's talent. The elder Corot went so far as to think that the award had in fact been meant for himself, having gone to his son through some bureaucratic blunder. He had no idea that this Fontainebleau landscape had aroused interest despite the continued reservations of the critics.

Though acquainted with Millet, Rousseau, and Charles Jacque, members of what would be known as the Barbizon School after a small village near Fontainebleau, Corot was to remain independent of this group, as of all other schools and movements. Nevertheless, he remained as fond of the Forest of Fontainebleau as when he had first visited it in 1822, and he continued to make numerous studies of its trees, as the drawings in the Moreau-Nélaton Collection, now in the Cabinet des Dessins of The Louvre, amply show.

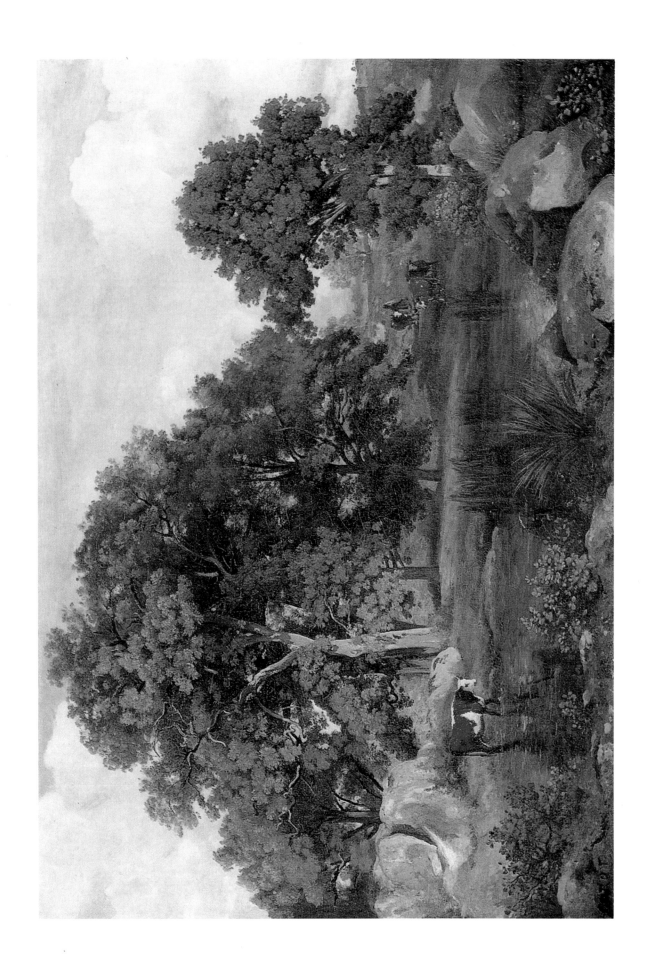

THE FAIR MAID OF GASCONY

Oil on canvas, 15³/₄ × 11⁷/₈″

Smith College Museum of Art, Northampton, Mass.

This splendid figure was once believed to have been painted toward the end of Corot's life; instead, it is one of the first in a series of half-length portraits which Corot began about 1850 and which continued right up to his death. Created while he was still working at 15 Quai Voltaire, this canvas—of which Corot was particularly fond—later hung in his studio at 58 Rue Paradis Poissonnière. We see a replica of it in *The Artist's Studio* (fig. 39), now in The Louvre, and in another canvas (fig. 38) in the National Gallery of Art, Washington, D.C.

The pigment in this work has a different appearance from earlier paintings; it is fairly thick and laid on with a broad, hard brush. The dull finish obtained in this manner allows Corot to achieve effects that he will continue in large figures executed later, such as *La Mélancholie* (fig. 36) and *Greek Girl* (fig. 34). The pose reflects a serenity and calm strength that evokes certain Graeco-Roman figures, not only for the expression but also for the monumentality, which is much greater than the actual dimensions of the canvas would suggest.

This work is undeniably an original creation, with no equivalent in the nineteenth century. Not until the Picassos of the 1923–24 period do we find figures comparable to this one. Picasso's *Greek Woman* (Collection Alex Maguy, Paris) and *Femme Assise* (fig. 33) are closely related to it both in treatment and in their feeling of calm strength, as well as in their compactness and their sculptural and timeless quality.

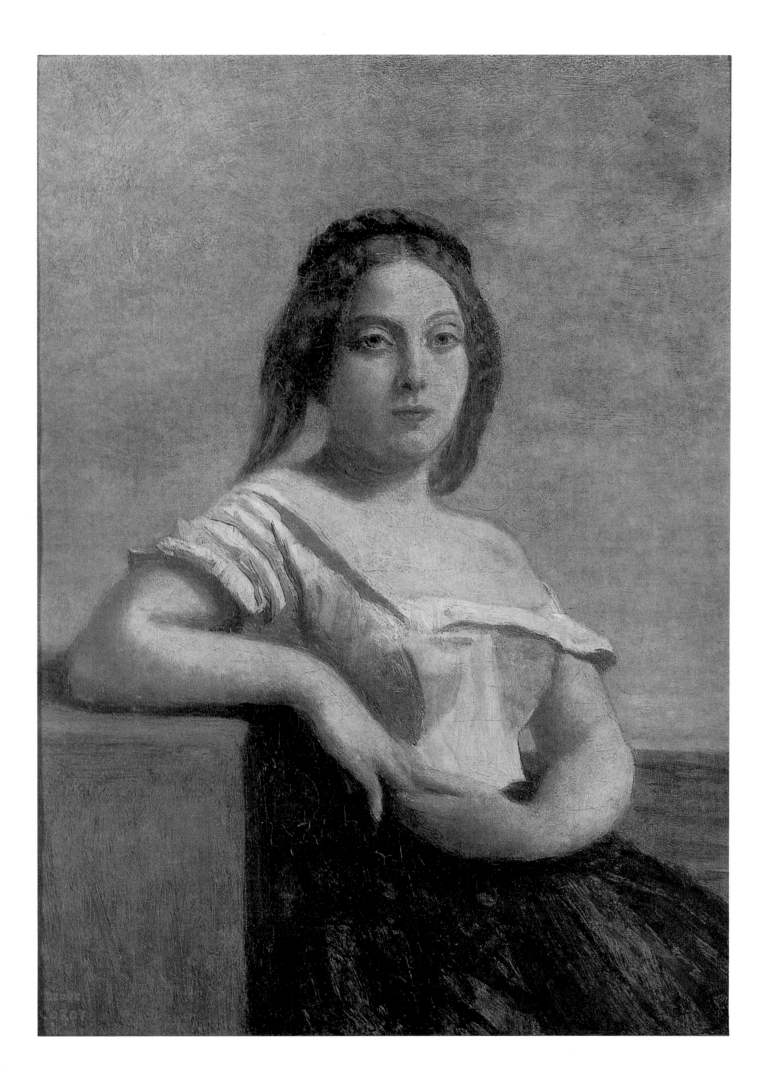

MORNING: DANCE OF THE NYMPHS

Oil on canvas, 38 ⁵/₈ × 51 ⁵/₈"

The Louvre, Paris

This painting marks a turning point in the evolution of Corot's style. Exhibited at the Salon of 1850–51, it was the first of a long set of variations on a theme that was to bring Corot wealth and even fame.

With *View of Volterra* and *The Port of La Rochelle,* Corot became aware of his ability to evoke the landscapes of Italy and the Charente region. Drenched in sunlight, these works are as logically constructed as a Latin speech, as well-ordered as a monument of classical art. At the same time he felt the challenge of rendering outlines in diffused light, of capturing the subtle effects produced by the damp atmosphere of northern France. He knew the region well from frequent trips to Arras to visit Constant Dutilleux and his family. Their home became a second home to Corot after 1851, the year of his mother's death. The melancholy feeling that invades his work at this time was probably due to a keen perception of the flight of time, as well as to a desire to render the diffusion of the northern light, as expressed by closely related values and silvery tones. The artist soon excelled in this manner, and it must have been easy for him, since from 1860 on he turned out a great number of compositions on this same poetic theme.

To provide for his friends and help the unfortunate, this generous man was to paint hundreds of pictures of lakes at twilight or shrouded in morning mists, peopled with nymphs and shepherdesses. They are always well painted, but one becomes aware of the formula. It should be added that if in such a painting as this one Corot's masterly hand is undeniable, the world market is cluttered with canvases executed in his life-time by pupils, friends, and copyists, not all of whom were honest enough to sign their own names. Corot, only too indulgent toward these less fortunate colleagues, would sometimes work over and finish their mediocre compositions, thus turning them into lucrative "real Corots." This we know from a hitherto unpublished letter Corot wrote two years before his death to his follower Oudinot (fig. 30).

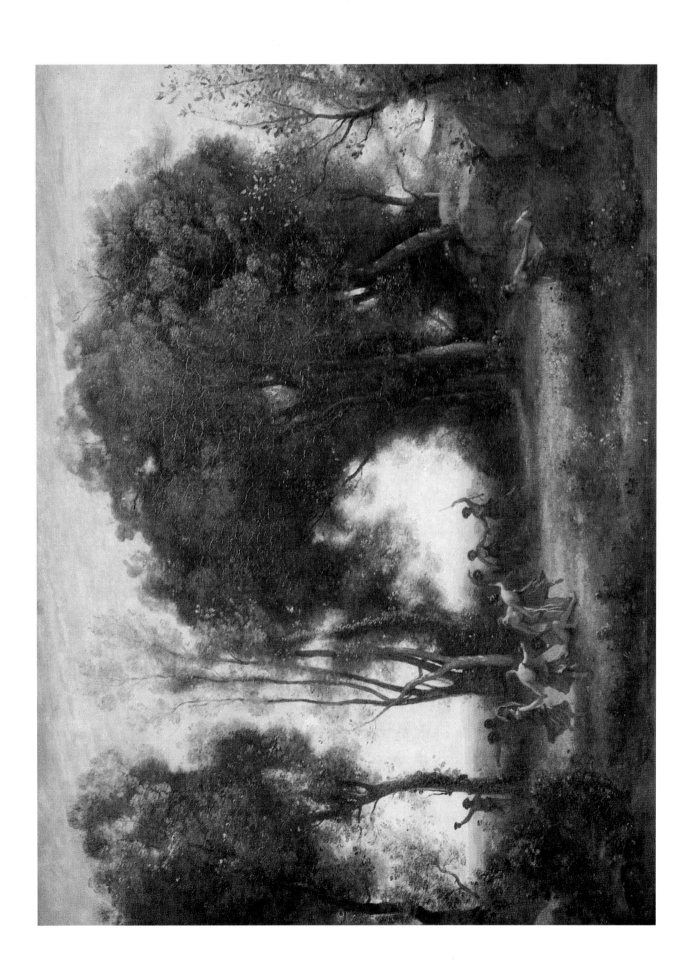

THE PORT OF LA ROCHELLE

Oil on canvas, $20^1/_8 \times 28^3/_8$"

Yale University Art Gallery, New Haven, Conn.

In 1851 Corot went to Brittany, and then down the Atlantic coast to Charente. This French province is famous for the beauty of its light. The combined effect of the rivers that water it, the mists rising from them, the light breezes, and the abundant rains alternating with bright sunshine give Charente an incomparable charm.

La Rochelle, a seventeenth-century port, is especially attractive for its subtle golden light. Corot arrived here in July, 1851, and in a house overlooking the town produced a highly harmonious series of paintings. Few of Corot's compositions are more accomplished, more golden, than this *Port of La Rochelle*. Free of any historical or poetic intentions, it is purely and simply a hymn of praise to light. The composition is balanced by the two towers and the church spire. Never have the subtle values that differentiate sky and water been better rendered. The solidity of Corot's composition had already been made clear twenty years earlier in his *Chartres Cathedral,* and it would still be so twenty years later in *The Belfry of Douai.* These three paintings done at different periods are the surest proof of his genius, which, as we shall see, had other facets as well.

The whole of nineteenth-century painting, and more than one aspect of twentieth-century painting, are essentially present in Corot.

This picture, painted from nature, was exhibited at the Salon of 1852.

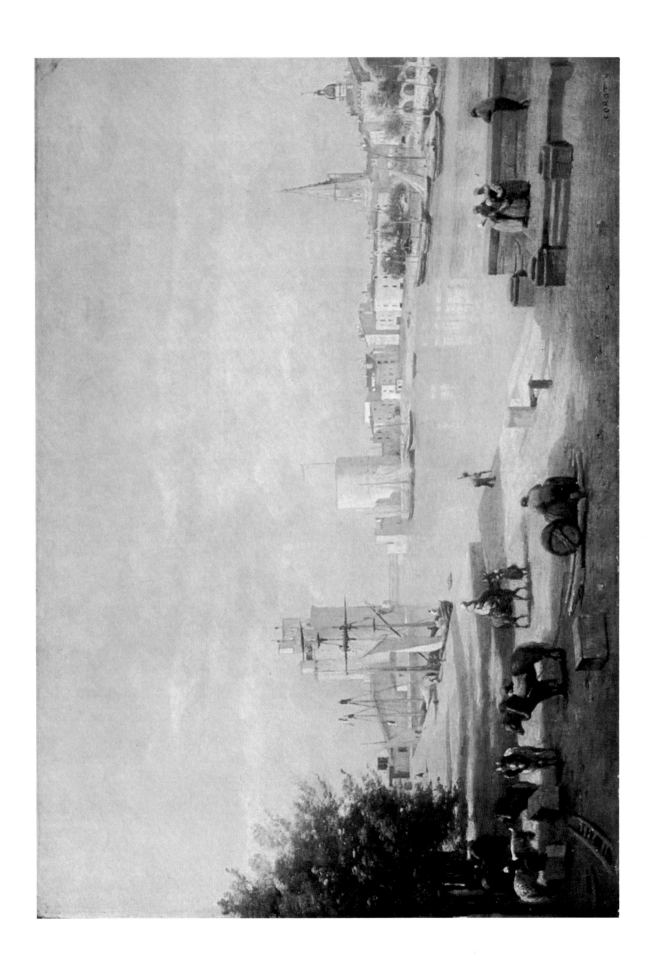

SAINT SEBASTIAN

Oil on canvas, 20^1/$_2$ × 11^3/$_4$″

The Louvre, Paris

The affinity between Corot and Rembrandt is indisputable when we study their respective palettes. Although that of the Dutch master is all golden nuances and Corot's silvery, both artists set themselves the same determined limits, and both reveal the same concern for rendering all the values, for laying out a broad underlying structure, and for indicating the essential aspects of the light in the first stages of creation. How much these artists have in common is further shown by the fact that their styles and their attitudes toward their subjects followed a similar course of development.

All this is particularly apparent in the work shown here. Corot painted it sometime during 1850–51, as a preliminary study for the large composition on the theme of the martyrdom of Saint Sebastian which he sent to the Salon of 1853. The latter shows the saint stretched out on the ground with two women who have come to tend his wounds after his ordeal. It is interesting to note that Delacroix called this painting perhaps the most religious the century had produced.

For a long time the study shown here was in the collection of Paul-Arthur Chéramy, Paris, where it hung next to Delacroix's *Christ on the Mount of Olives* and lost nothing by comparison.

A photographic detail of Saint Sebastian's face (fig. 24) reveals a broad, flexible impasto that underscores the resemblance between this picture and Rembrandt's *Saint Matthew and the Angel* (fig. 25).

The boldness of treatment of the body, its dramatic appearance made more dramatic by the setting, gives this little work a moving quality that well conveys the suffering of a helpless, naked man exposed to the arrows of vicious persecutors.

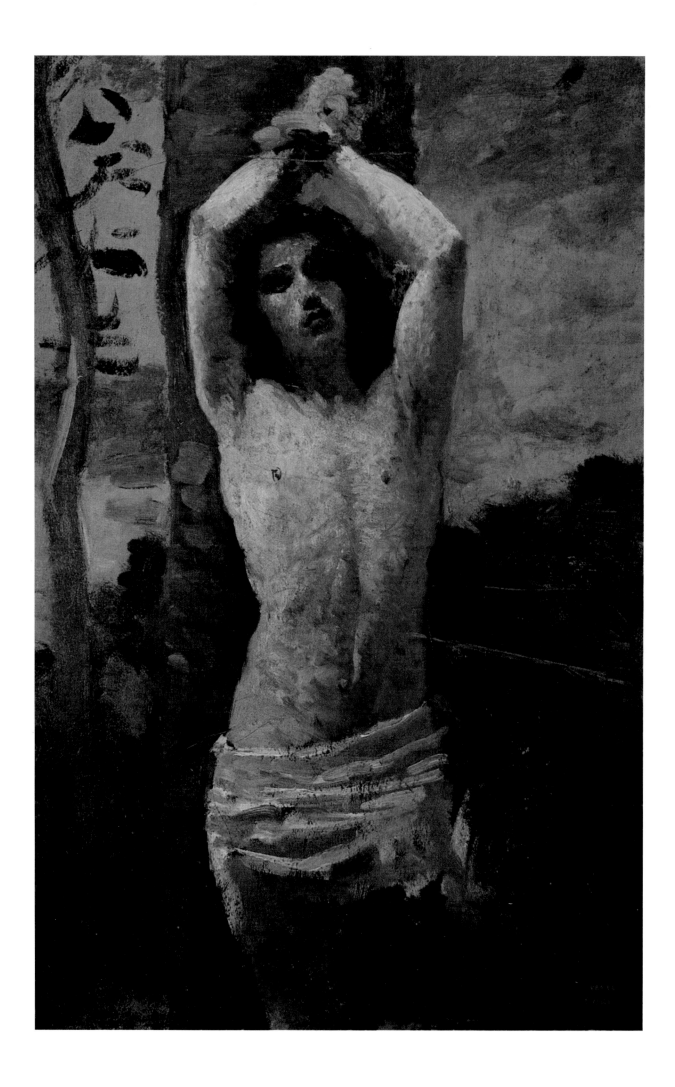

MUR (CÔTES-DU-NORD)

Oil on canvas, 13 × 21⁷/₈"

John G. Johnson Collection, Philadelphia

This work was painted by Corot in Brittany, probably in the village of Mur-de-Bretagne. In 1855, the artist wrote to Hector Leroux, one of his pupils: "So you don't come to Paris in winter any more? In May I have usually left town. I am thinking of visiting you for a week, but I don't yet know whether that will be before going to Normandy and Brittany in the Côtes-du-Nord."

The trip produced two paintings. The one shown here (Robaut No. 685) is extremely bare. Its apparent simplicity of line is enlivened by the figures of Breton girls, wearing the local peasant cap, who disport themselves around a spring that is surrounded by a stone wall. All of Corot's skill is displayed in the way he renders irregularities of the terrain with subtle differences of tone. Though almost monochrome, the composition is a masterpiece of luminosity. The work conveys the artist's own pleasure in painting it.

This pleasure is confirmed by the fact that he painted another work on the same subject and on the same site, very likely within a few days of this one. It gives a closer view of the spring, with the wall in the foreground as the center of the composition, around which the painter has assembled a group of women and girls. The picture, now in The Louvre, employs very nearly the same palette as this work; the difference lies in the rough-hewn, sculptural, static character of the figures, who, instead of enlivening the Breton landscape, seem as integral a part of it as the rocks.

During this period, to satisfy his public, Corot was exhibiting pastoral scenes with dancing shepherds and shepherdesses, poetic landscapes in which the forms dissolve in morning mists, while at Mur-de-Bretagne he executed these small paintings faithful to the ruggedness of the Breton terrain. Together they show the range and variety of his art.

RECLINING NYMPH

Oil on canvas, $19^1/_4 \times 29^1/_2$"

Musée d'Art et d'Histoire, Geneva

François Fosca tells us that whenever Degas went to Geneva to see his brother, he never failed to visit the museum of that city in order to admire the works of Liotard and Corot. He regarded the *Reclining Nymph* as a masterpiece. It is one of the earliest works in which Corot made the nude his essential subject. Later he did many works displaying soft reclining bodies in deliberately unspecified landscapes that impart a timeless harmony to these compositions. The work shown here, like the *Bacchante with Panther* (Collection Mr. and Mrs. Harry Payne, Bingham, New York) and *Nymph Reclining on Seashore* (The Metropolitan Museum of Art, New York), is a superb example of pure painting.

The body of the nymph is realistic without being assertive, for its outlines are dissolved in the light and integrated within the poetic landscape. The very soft yellow of the cloth creates an exquisite harmony between the body and the grass, an effect that shows Corot's mastery and is equalled only by Vermeer.

The somewhat short proportions of the young woman foreshadow a less academic conception of the human body, which will later be shared by such a sculptor as Maillol. Here, too, Corot is a precursor of twentieth-century art.

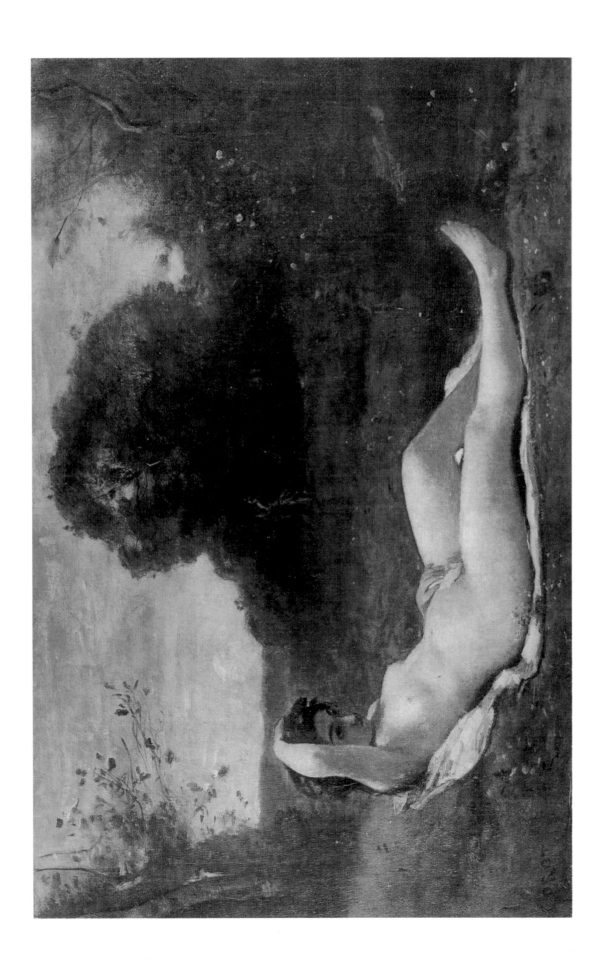

THE MOTHER SUPERIOR
OF THE CONVENT
OF THE ANNONCIADES

Oil on canvas, $14^1/_8 \times 9''$

The Louvre, Paris

This work was painted at the request of the painter Desbrochers, whom Corot occasionally visited in the north of France. The Mother Superior of the Convent of the Annonciades was related to the Desbrochers family. Shown here in the habit of her order, she is a figure of great dignity. Her noble costume goes back to the fifteenth century; it was designed by Sainte Jeanne de France, the daughter of Louis XI, who founded the Annonciade order at Bourges.

It seems certain that, with the connivance of his sitter, Corot has here set out to produce an official portrait. Because of the stress laid on the nun's habit, her individuality might be said to disappear under the emblems of her order.

Once again Corot has transformed a triangular mass into a solid composition, with a skill that continues the traditions of the seventeenth-century French masters. This composition evokes in particular the portrait of Richelieu by Philippe de Champaigne, but it is marked in addition by a boldness of color, a firmness of drawing, and an austerity that account for the admiration painters of the Cubist era had for Corot's figures. This portrait is one of his most interesting, if only for the originality of the subject.

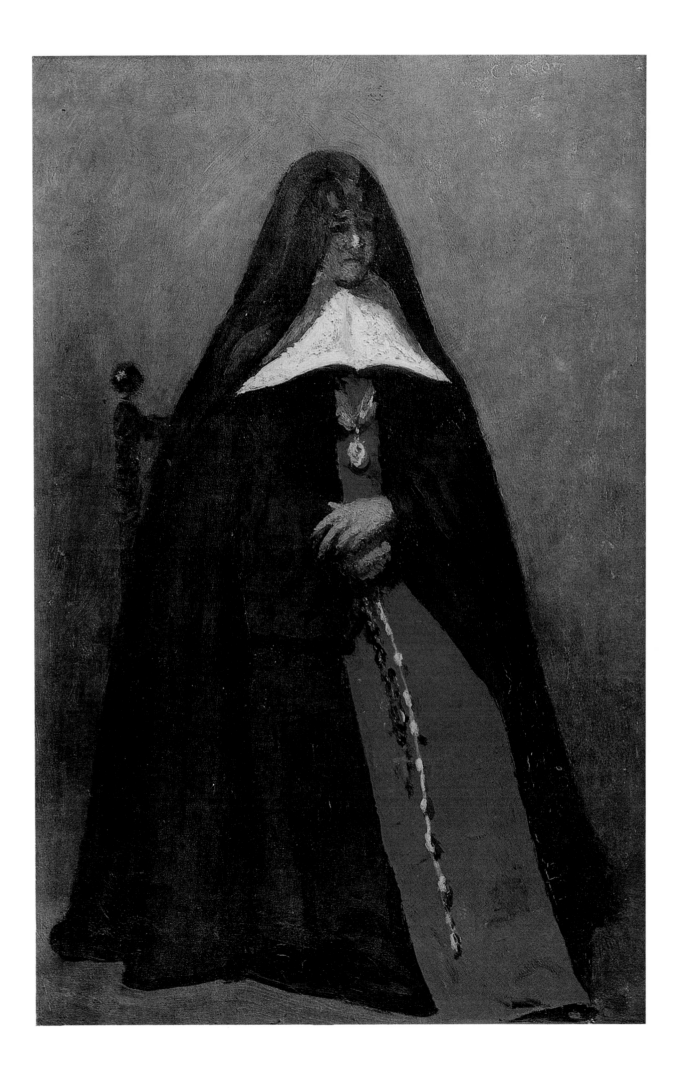

MAURICE ROBERT AS A CHILD

Oil on canvas, $11\,^3/_8 \times 9$"

The Louvre, Paris

Portraits of children occur at intervals in Corot's work between the years 1843 and 1857. They are usually small in size, and represent the model either full- or half-length. These were the children of his friends, and we know that Corot had a fund of patience and respect for children, as can be seen in these compact and observant works.

Here the model is the son of Louis Robert, the magistrate whom Corot often visited at Mantes. About four years old, the boy wears a gray costume trimmed with silk. His grave and thoughtful expression is rendered with incomparable skill, and photographic enlargement (fig. 32) reveals the softness of the features. As though it were the subtlest of landscapes, Corot has caught the fragile beauty of a face as yet untouched by the stresses of life.

Some years earlier, about 1843–44, Corot had painted Maurice's older brother, Louis; that same year he did the portraits of the grand-children of his old employer, the textile merchant Delalain, as well as a portrait of the son of the painter Desbrochers. These graceful works are eloquent testimony to the artist's respect for childhood.

The boy who sat for this picture kept it and left it to his sons Christian and Maurice in his will. In 1926 they made a gift of it to The Louvre, along with Corot's decorations for the bathroom in the family home at Mantes.

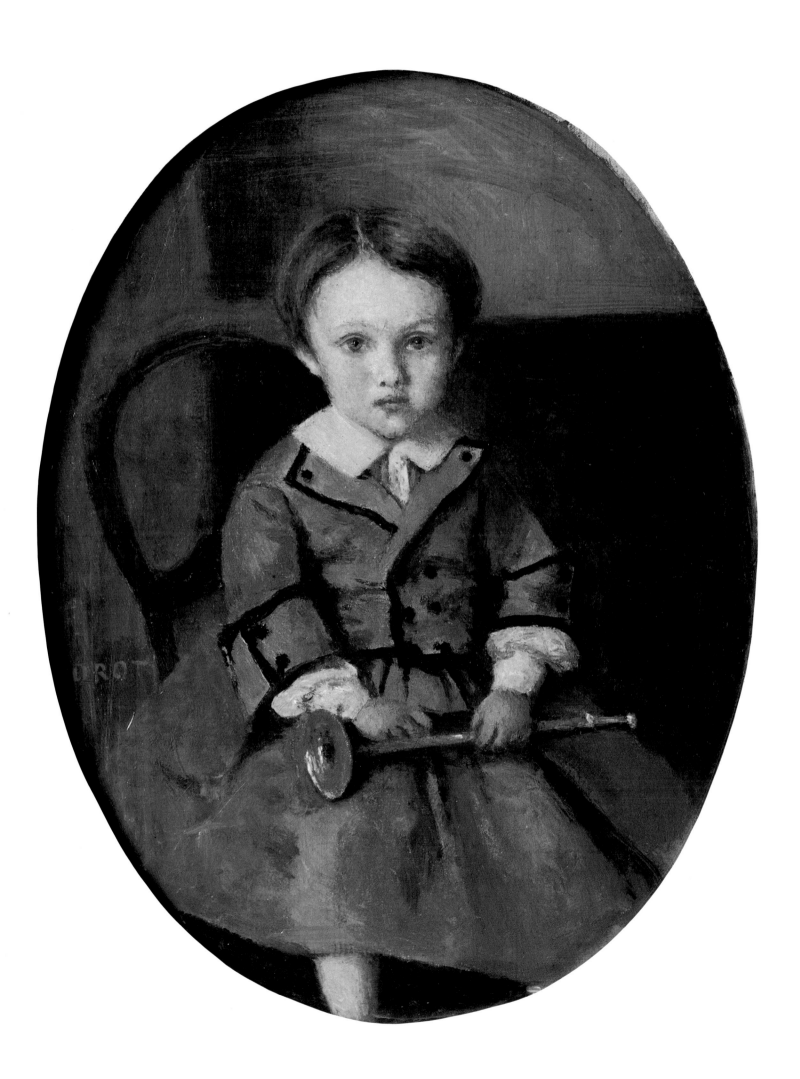

THE QUAI DES PAQUIS IN GENEVA

Oil on canvas, 13³/₈ × 18¹/₈″

Musée d'Art et d'Histoire, Geneva

According to Bazin, this work was executed in 1859; according to Baud-Bovy, in 1863. Whatever the case, this Corot painting is a marvel of construction. Not a single line could be shifted without altering the composition, in which the contrasts between light and shadow, and the sharp angles foreshadow Marquet and even the Cubists. Later Corot was to employ a more subtle palette, but here, still under the influence of classical French and Italian painting, he lavished all his attention on the composition. We know from Baud-Bovy that he devoted more than twenty sessions of two hours each to this work.

In 1842, Corot wrote to the painter Paul Tavernier: "For the time being I am stopping in this charming city, Geneva. . . . Last night in my hotel room I reread the following lines by Jean-Jacques Rousseau, that landscapist of genius: 'Just looking across the Lake of Geneva and around its splendid shoreline has always had a special attraction for me which I cannot account for. It is not only the beauty of the spectacle, but something more touching that affects and moves me.' " These words (published in the *Tribune de Genève* in 1947, and here quoted from François Fosca) confirm what we already know from other sources, that Corot felt close to Rousseau and the ethical naturalism of the eighteenth century. Moreover, Switzerland had been the home of his maternal ancestors.

Around the time when he wrote the letter to Tavernier, Corot painted a view of Geneva from the lake shore (fig. 23), which is in the John G. Johnson Collection in Philadelphia.

The Quai des Paquis is an austere work. Interest is centered on the contrast of the surface of limpid water between the dark mountain and the foreground, the boldest demonstration of Corot's mastery and knowledge of composition. Not until Marquet in the twentieth century did an artist again utilize the value of a plane of water, and by its context produce a work most satisfying to our sensibility in spite of—or because of—its very simplicity (see fig. 47).

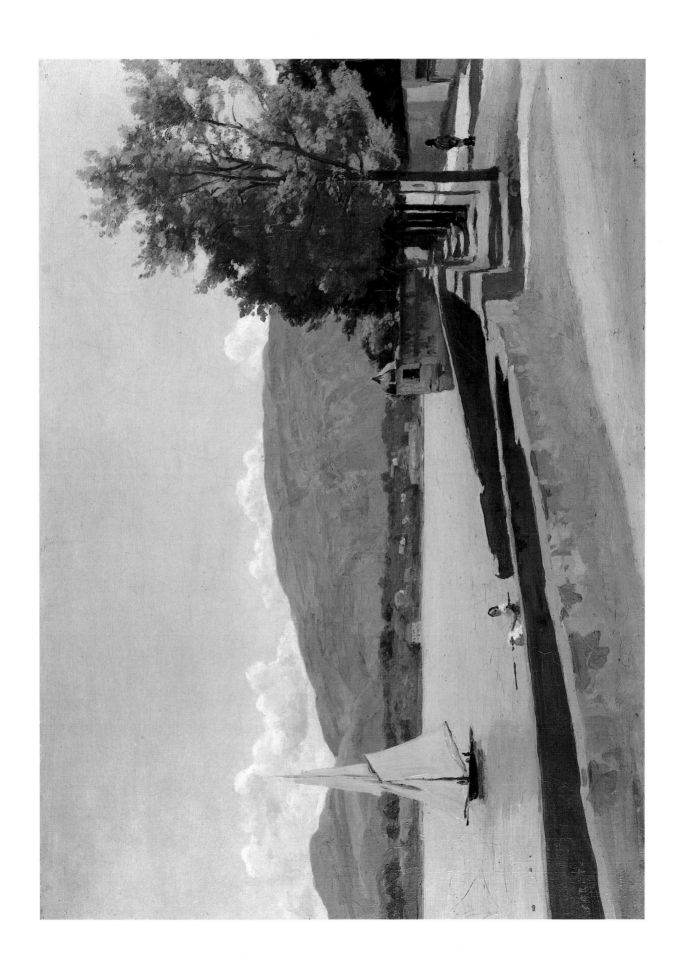

MOTHER AND CHILD ON THE BEACH

Oil on canvas, $14^7/_8 \times 18^1/_8''$

John G. Johnson Collection, Philadelphia

Groups are rare in Corot's work; this one is surely the most moving and most original. Everything in it contributes to stressing the ties between mother and child, who form virtually a single figure. The young woman's back and skirt initiate a circular movement that envelops the child, and integrates it with the mother and the central composition. The fragile child forms a soft circle at the end of the two round white arms stretched toward it. There is hardly a more unexpected composition in all of French art, one in which the play of lines and forms more effectively serves one's understanding of the painting.

Corot rarely treated this subject, but it may be noted that around 1855 he painted a *Mother Protecting Her Child* (fig. 21), later reworked, which is in the Philadelphia Museum of Art. There is also the *Breton Woman and Her Daughter*, composed about 1855, a small oil on wood (present ownership unknown). Its simplicity, sense of proportion, and composition relate it to the work shown here.

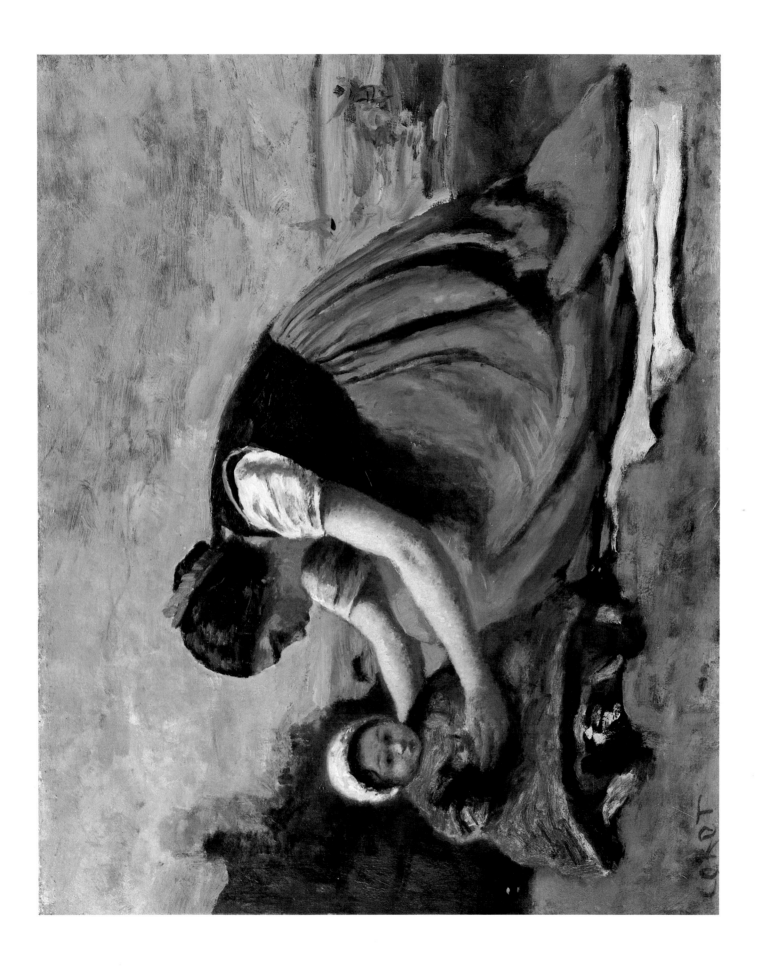

RECOLLECTION OF MORTEFONTAINE

Oil on canvas, 25⁵/₈ × 35"

The Louvre, Paris

This painting enjoyed a resounding success at the Salon of 1864. It was purchased by the government and hung in the palace of Fontainebleau, before being added to The Louvre collection in 1889.

The ethereal landscape shown here does not give up its riches at first glance. Like most of Corot's works of this period, it seems wrapped in haze, but what enchantment it holds!

In 1897, Lafond wrote in *Les Chefs-d'oeuvre*: "Never has Corot, that impeccable master, given a better rendering of nature's delicate morning charm. . . . Never has the great artist captured more felicitously, among the various and changing aspects of nature, one so perfectly suited to his art."

Watteau had painted in the vast park of Mortefontaine, which is situated about eighteen miles north of Paris. It is an area of small lakes and woodlands, and some rare species of trees were planted there in the seventeenth century. Corot was enchanted with this poetic spot, and the present owners have taken the trouble to identify the sites where he worked and to preserve intact the vistas which inspired him. One small preliminary oil study for this canvas and several drawings have survived.

Corot attempted a few variations on this composition, one of the finest being *The Boatman of Mortefontaine*.

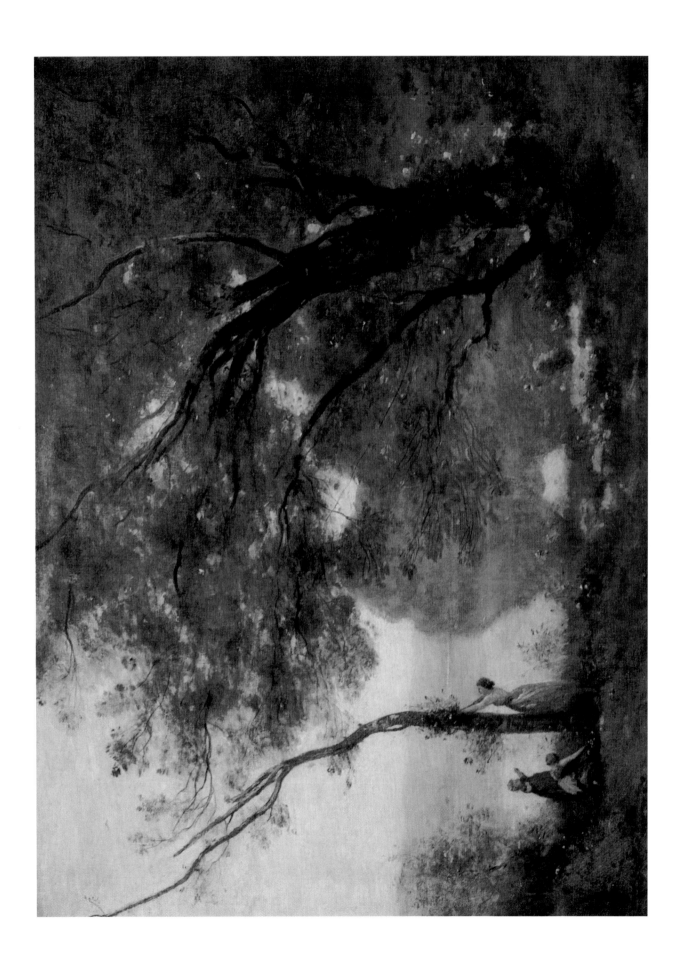

Painted in 1865–70

THE BOATMAN OF MORTEFONTAINE

Oil on canvas, 24 × 35³/₈"

Copyright the Frick Collection, New York City

This canvas was probably commissioned by J. Crabbe after the great success of the *Recollection of Mortefontaine* at the Salon of 1864. The two works are closely related, and it is interesting to compare them. The composition is the same, the only difference being the poses and arrangement of the figures. The subject is treated more realistically, and the light lacks the poetic character it has in the other work.

Many artists among Corot's contemporaries treated the same theme with or without his consent, but careful study of details makes it possible to distinguish the master's hand from those of his imitators. Corot's mastery is particularly apparent in the evocative quality of his human figures. Though briefly sketched, they convey all the grace of youth, as in the *Recollection of Mortefontaine*, or, as in the work shown here, the intentness of the man at his work, rendered by Corot in only a few strokes. Accordingly, one of the easiest ways to detect imitations or copies of Corot's work is by the weakness of the figures, which robs the picture of its soul and meaning.

Mortefontaine is one of Corot's most frequently treated themes. Bazin believes that in these works evoking the lake, Corot was influenced by studies he had made many years earlier on the shores of Lake Nemi. There is no question that Corot was especially drawn to the spectacle of serene waters surrounded by trees, and his many works may well, on occasion, synthesize impressions gathered at Lake Nemi, Mortefontaine, Ville-d'Avray, and other places besides. The geographical origin of the theme does not matter so much as the evocative power of the composition.

THE STUDIO:
YOUNG WOMAN WITH A MANDOLIN

Oil on canvas, 22 × 18 ¹/₈"

The Louvre, Paris

In front of a canvas standing on an easel, a young woman holding a mandolin seems lost in melancholy thought. It would appear that what we have here is an allegory: the graceful model has a timeless quality that suggests certain figures by Vermeer, though Corot's colors are different. The model's bodice is bright red, as is the ribbon in her hair, but the more subdued tones of the long skirt harmonize the composition. The face is bathed in light falling from the skylight.

Corot treated the theme of the painter's studio several times between 1865 and 1870. In one version (fig. 39), also in The Louvre, and in another (fig.38) in the Widener Collection (The National Gallery of Art, Washington, D.C.), the less cluttered wall in the background and the stove with pipe at the left impart a more realistic character to the composition. A slightly larger version with the same title (fig. 40), in the Musée des Beaux-Arts at Lyons, holds the viewer's interest despite the hastily sketched setting.

Surely in the work shown here the artist has succeeded in rendering the atmosphere of the studio at 58 Rue Paradis Poissonnière which he had occupied for twelve years. On a lower floor of the same building he had an apartment, where he lived and was looked after by a devoted servant. It was during his years at this address that Corot achieved his tardy but considerable success.

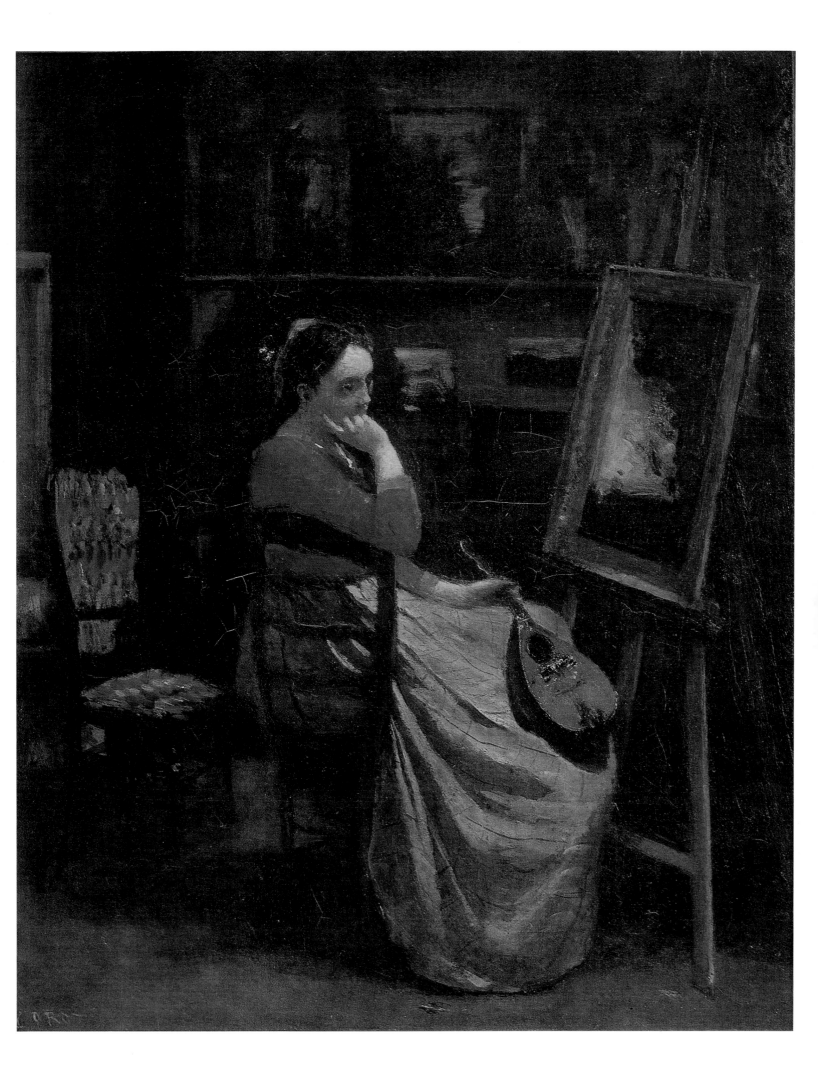

WINDSWEPT LANDSCAPE

Oil on canvas, 18 $^1/_8$ × 22 $^7/_8$"

Musée des Beaux-Arts, Reims

Here Corot shows us a once-peaceful landscape transformed by the approach of a storm—the clouds scudding, the trees bending in the wind. Several versions of this theme exist; they are by no means identical, but all of them, according to Bazin, derive from a study that Corot made outdoors and that Robaut published as his No. 1132, *Recollection of a Gust of Wind at Cayeux.*

Windswept Landscape was exhibited at the Salon of 1867, along with *The Church of Marissel,* which was unanimously acclaimed. This picture must have contributed to Corot's success, for he was awarded another medal at the Salon and promoted to the rank of Officer of the Legion of Honor.

With public recognition, Corot lived like a master, constantly surrounded by friends and pupils. When he looked back on the lean years, he would say: "How wonderful it is to discover at last that I am an interesting man, but what a pity my father did not live to see it—he resented my painting and could never find anything good in it because it didn't sell."

This was no longer the case. In 1867, Corot also won acclaim at the Exposition Universelle with seven paintings, and in the preceding year Napoleon III had bought *Solitude* for the considerable sum of 18,000 francs.

The painting shown here, though executed in the studio, shows so keen a sense of observation, such truthfulness, that every detail contributes to the over-all impression. It is a good example of Corot's realistic vein, which he never ceased to practice even while continuing to produce his poetic compositions entitled *Recollections.*

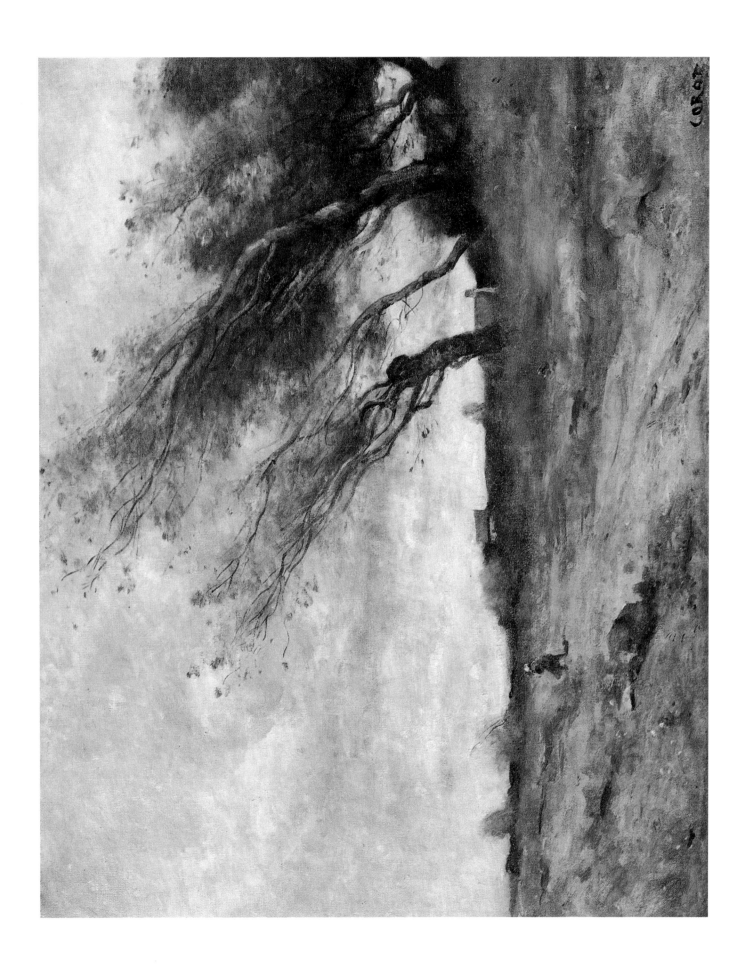

AGOSTINA

Oil on canvas, 52 × 37³/₈"

The National Gallery of Art, Washington, D.C. Chester Dale Collection

This large figure painting is one of Corot's finest works, and was directly inspired by the great portraits of the Italian Renaissance. It has the detachment, objectivity, and dignity of a Raphael figure, and the serenity of a Piero della Francesca, and yet all the elements in it are characteristic of Corot's art.

The light, airy landscape in the background seems to consist entirely of nature's most fugitive aspects: the fading light, the last leaves on the tree. The sculpturesque treatment of the model, whose serenity is such that she might be immortal, stands out in the strongest possible contrast.

This painting entirely justifies the admiration shown by Renoir and Degas for Corot's figure paintings, which went unappreciated by his contemporaries, who preferred his poetic landscapes. In his large portraits, Corot attains mastery within a genre where French painters have always excelled. Today we regard them as among his best works, along with the landscapes painted directly from nature, which also had less success than his studio compositions.

It is easy to see from this picture why Cézanne was so interested in Corot's figures. The sense of construction, the search for density, are goals common to both artists.

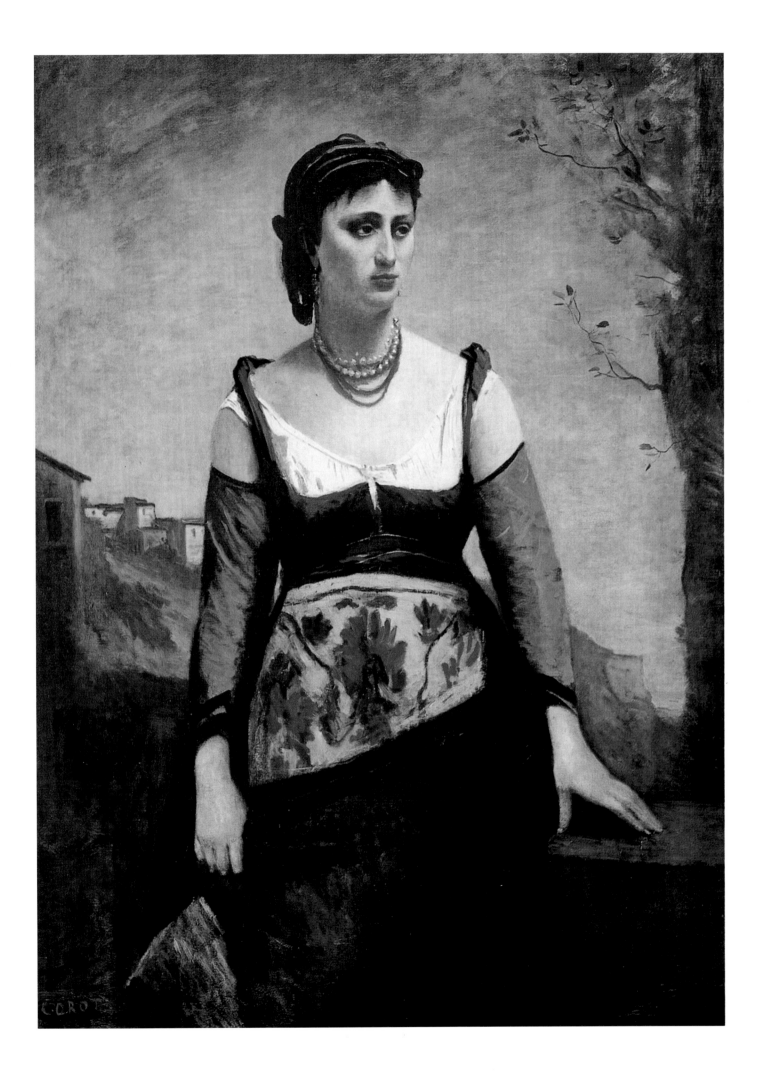

THE CHURCH OF MARISSEL

Oil on canvas, $21^5/_8 \times 16^7/_8''$

The Louvre, Paris

Marissel is a village near Beauvais, where Corot painted many fine works. On repeated visits to the region he stayed at an estate at Voisin-lieu, owned by an amateur painter named Wallet, and made several studies in the park. Of Marissel itself we have a number of views, the finest of which is probably the one shown here. It was painted early in the morning, for Corot enjoyed painting before the sun was high in the sky. We know that this work took him eight or ten sessions. We also know from an article by G. Varenne ("Corot on the banks of the Thérain," *La Liberté*, September 15 and 16, 1903) that the artist omitted a fence and thinned out the trees bordering the road.

When exhibited at the Salon of 1867, this painting impressed critics and collectors alike. Queen Victoria was immensely pleased by it and was vexed to learn from her emissary that the canvas had already been sold to a tailor, Laurent Richard, for 4,000 francs.

That same year Paul Mantz, the critic of *L'Artiste*, wrote: "The view of Marissel is a jewel, a simple study as nature dictated it to the artist: a path with two lines of trees leading up to the pointed steeple of the church. The effect is gray, but it is a golden gray, warmed by exquisitely delicate light tones. There is a great deal of art in this seeming simplicity and a great deal of poetry."

We in turn can only agree with this judgment. Corot's studies from nature hold more lasting attractions for us than the poetic landscapes he executed in the studio.

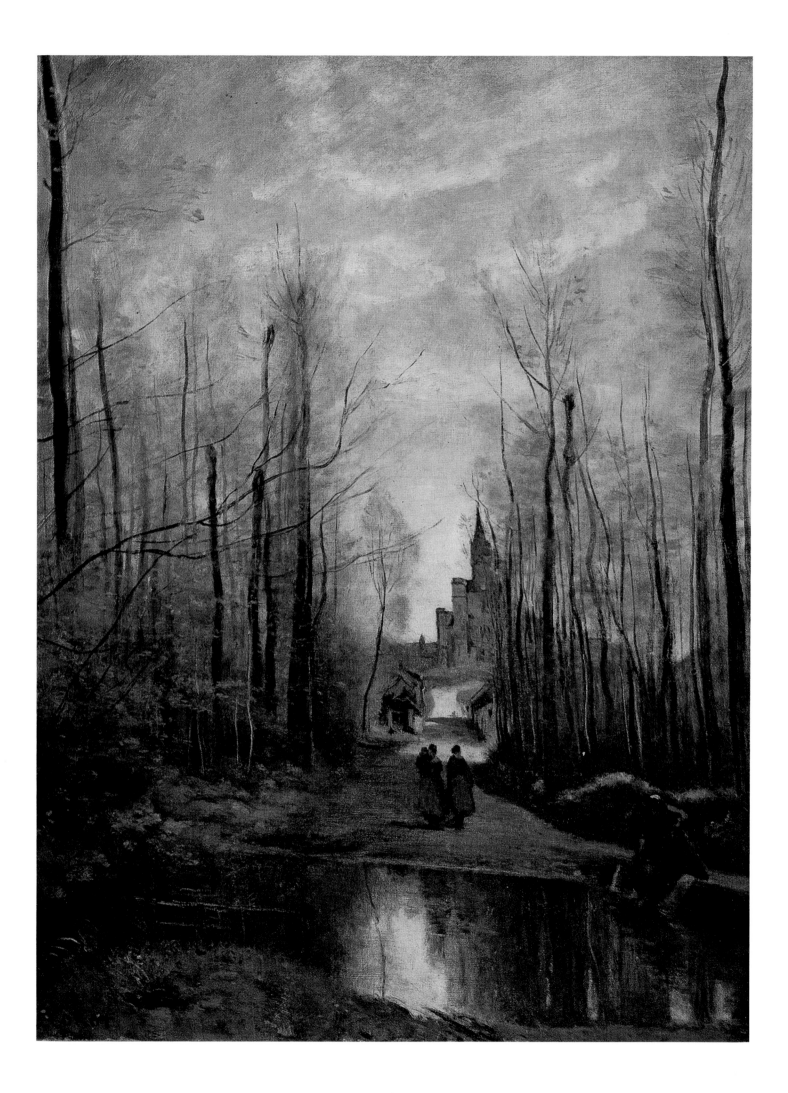

VIEW OF MANTES

Oil on canvas, $20^1/_2 \times 12^5/_8''$

Musée des Beaux-Arts, Reims

From 1840 on, Corot often painted at Mantes, where he stayed with his friends the Roberts. Two medieval structures—the old bridge and the cathedral—especially attracted him.

In the rightness of its poetic effect, fidelity of observation, and sureness of treatment, this view of the church at Mantes yields nothing to works executed many years earlier, such as *Chartres Cathedral.*

The museum of Reims has two canvases showing the apse of the Mantes cathedral, painted about 1865–70, one in vertical format, the other horizontal. A few years earlier, Corot had already experimented with the same motif in a painting now in the United States.

The *Bridge at Mantes* is in the same realistic vein, but its realism is transcended by the poetic emotion produced in the artist by the fleeting quality of the light on the noble lines of the old masonry.

Corot wrote in a notebook in 1856: "While I aim at conscientious imitation, I do not for one moment lose sight of the feeling that has taken hold of me. Looking at a particular object or place, we are touched by a certain grace and should not lose sight of it. While aiming at truth and accuracy, let us never forget to clothe it with the appearance of what has touched us. Let us trust our first impressions."

After The Louvre, the museum of Reims has the largest single collection of Corots. Set up by a number of donors who admired the artist, it mostly contains works that were executed or reworked in the studio, the great paintings done directly from nature being mostly in The Louvre and in American collections. During the artist's lifetime, twenty-eight canvases acquired by the State or by municipalities were distributed among a number of French museums.

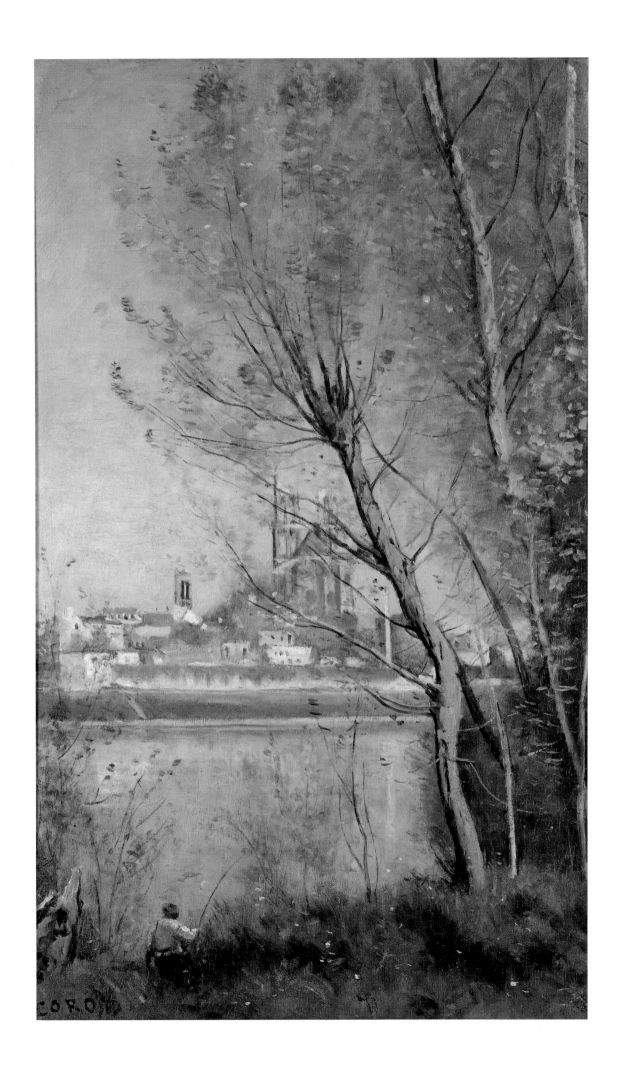

WOMAN WITH A PEARL

Oil on canvas, 27 ⁵/₈ × 21 ⁵/₈″

The Louvre, Paris

The model for this portrait was probably Berthe Goldschmidt, whose parents had a store not far from Corot's studio. The over-all feeling of the picture, especially the girl's pose, brings to mind Leonardo's *Mona Lisa*. In 1952, Germain Bazin had the happy idea of hanging the two pictures near each other, and there can be no doubt of the relationship. As Corot grew older, a mood of melancholy daydreaming became increasingly pronounced in his painting.

Radiography (fig. 41) reveals that in its early stages the work was more realistic and less poetic. The subtlety with which the various grays are harmonized is complemented by the way the paint has been applied, thickly and densely, with firm strokes. As the art historian Henri Focillon wrote: "The values are the exact measure of the light on the surface of the bodies, and in their local rightness and over-all relationships constitute what is so rare and personal in Corot's art." Rarely do we find a painting in which the values are subtler than those in this portrait.

Corot himself seems to have held this work in special esteem, for it hung in his drawing-room until his death.

A replica of this portrait was executed by Eugène Devé, and is now in a private collection.

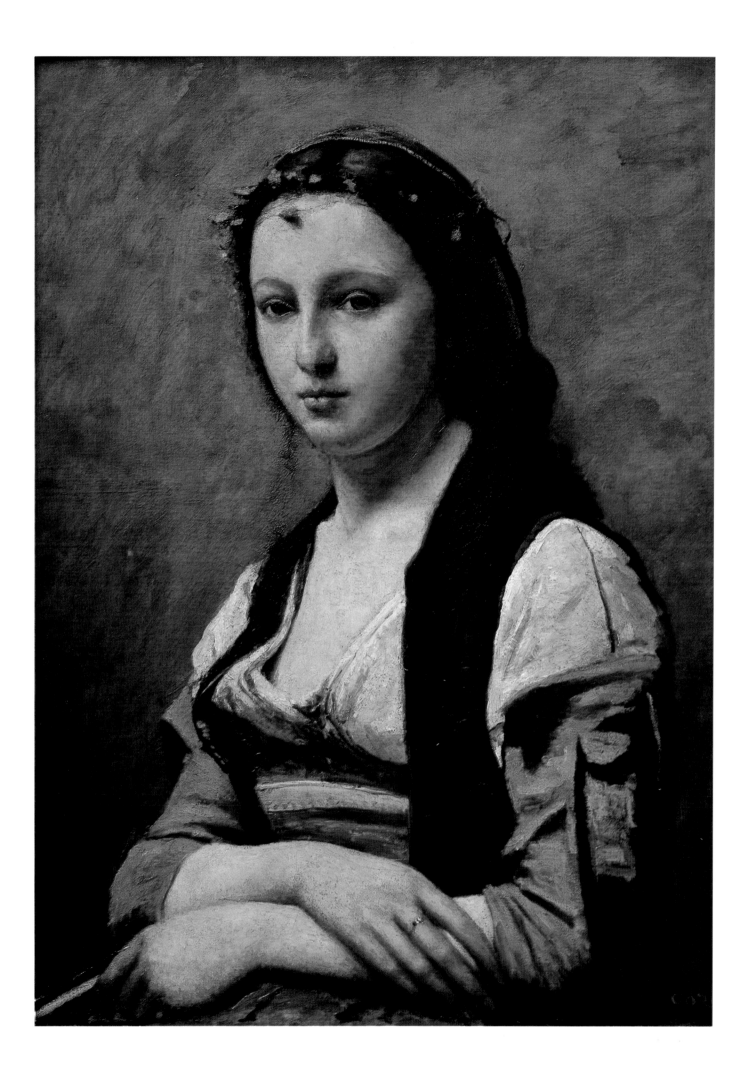

THE BELFRY OF DOUAI

Oil on canvas, 18 1/8 × 15"

The Louvre, Paris

After living in Paris throughout 1870, the terrible year of the French defeat at Sedan and the Paris Commune, Corot left for Douai in May, 1871. Not long after, he wrote to his friend Desavary: "I am putting the final touches on *The Belfry of Douai*—it's terrific."

Corot completed the painting in twelve sessions according to some, in twenty according to his friend and biographer Robaut. The work was done from a room in a house owned by a certain M. Hurnez, which afforded a direct view of the belfry. Working with determination, Corot refused all visitors, and did not permit himself the least distraction. The complex architecture of the belfry presented one difficulty after another. Deservedly famous as he now was, he painted without respite, revising the picture until he had succeeded in rendering the subtlety of the tower's outlines as seen in the damp air of this region of northern France.

This masterpiece is closely related to *Chartres Cathedral*, dating from the artist's youth, a work he kept most of his life and of which he used to say, "*C'est un fameux.*" On its back he had written, "*Pour le Museum des Arts.*" He always intended the *Belfry* and the *Chartres* to go to The Louvre, which, incidentally, he simply called "the Museum," thus revealing his eighteenth-century origin and upbringing. One of the first creations of the Convention in the decade of the French Revolution was what we today call "The Louvre," but which its founders called the "Museum of the Arts."

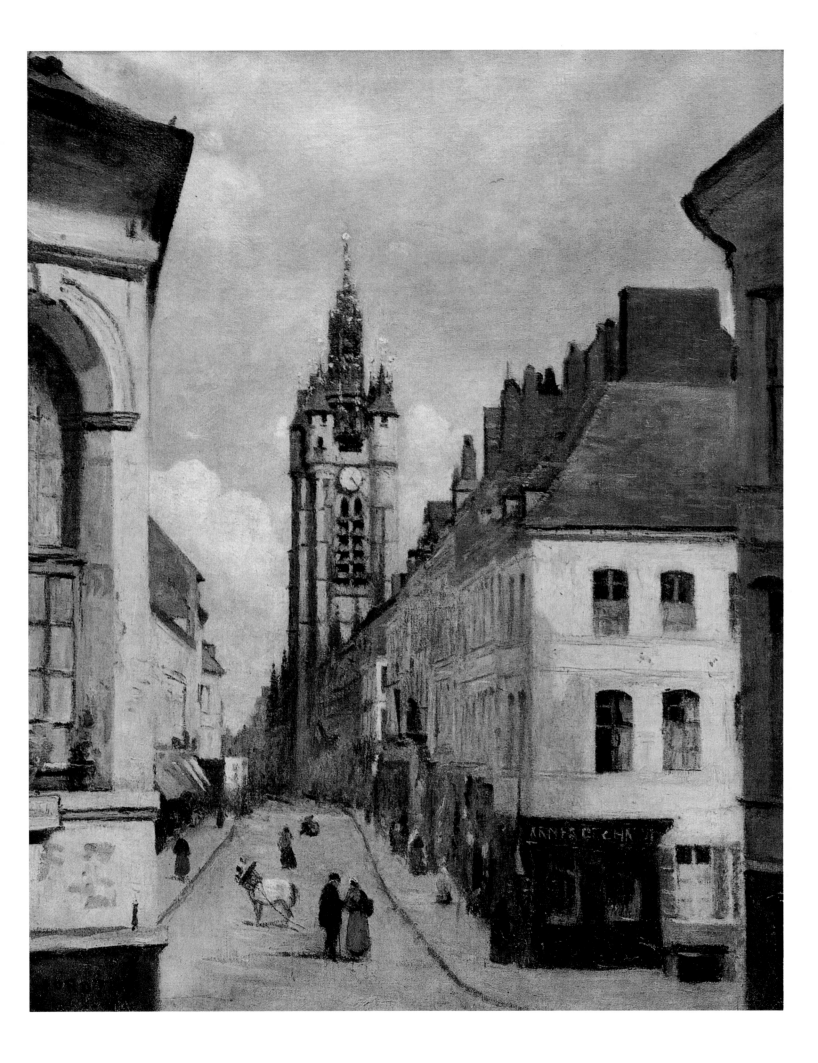

MLLE DE FOUDRAS

Oil on canvas, $22\,^7/_8 \times 14\,^1/_8\,''$

Glasgow Art Gallery and Museum

This composition is classical in concept and skillful in rendition. The model seemingly absorbed in her own thoughts brings to mind the *Mona Lisa,* as does also Corot's *Woman with a Pearl.* The soft arc formed by her arms seems to emphasize the sitter's humanity; her face is pensive, and there is nothing secret about her melancholy. Mlle de Foudras was the daughter of a tobacconist whose store was in the Rue Lafayette, near Corot's studio in the Rue Paradis Poissonnière. One imagines that her grace and elegance touched the artist, who painted this picture around the year 1872, when he was at the peak of his fame. His was a fame that did not allow him to forget the harsh years of solitude that had left their mark on his own features, and which he was to discover with profound insight in this young woman's loneliness. To us she appears as an allegory of uprootedness.

The technique revealed in this portrait is fluent, the brushstroke broad and seemingly flattened, suggesting the use of a palette knife. The mat colors further contribute to the impression of refinement. Once again we are reminded of Rembrandt, for the similarity in the development of his and Corot's painterly technique is obvious. The spare, compact brushstroke characterizing the portraits Rembrandt made about 1630 is also that of the young Corot about 1830, as in the portrait of Alexina Ledoux.

Between such earlier portraits and the work shown here lies Corot's entire artistic development. The liberation of his style corresponds to a mastery of technique which, along with understanding, a breadth of vision, and an avowed but controlled sensibility, makes this composition the profoundly moving one it is.

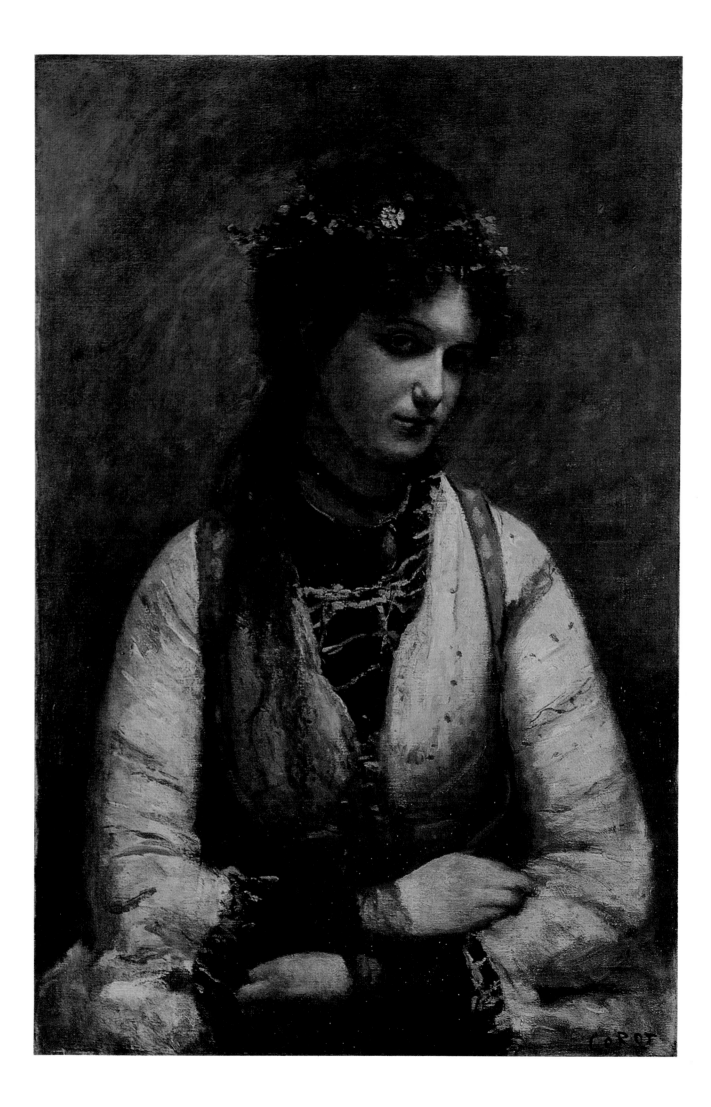

YOUNG ALGERIAN WOMAN
LYING ON THE GRASS

Oil on canvas, $15\,^3/_4 \times 23\,^5/_8{}''$

Rijksmuseum, Amsterdam

This picture was painted in Corot's studio in Paris in 1871 and re-worked in 1873.

It is obvious enough that neither Corot nor his model had ever set foot in Algeria. What we have here is a variation on the "Oriental" theme, a tribute to the influence of Delacroix. The latter's famous oil, *Women of Algiers* (fig. 43), exhibited in The Louvre, and the numerous drawings he brought back from his journey to Africa contributed to the new vogue of exoticism in the arts—as had General Bugeaud's conquest of Algeria in 1830. Corot's *L'Albanaise* and *Greek Girl* (figs. 34, 35) are in the same vein. The influence of Delacroix's themes is most apparent in Corot's work from 1868 on, whereas twenty years earlier he had denied being attracted by Romantic ideas.

Radiographs (fig. 42) made when this painting was exhibited at The Louvre in June, 1962, reveal one important alteration in the composition. Originally the young woman's left leg was raised and bent at the knee. A photograph of the painting taken by Desavary in 1872 in Robaut's studio at Arras confirms the discovery, for what Desavary photographed was the picture as Corot had painted it in 1871 and before he had reworked it in 1873. The radiographs further disclose a brushstroke so fluid and vibrant as to suggest the experiments of the Impressionists.

This work is extremely interesting for what it reveals about Corot's psychology. Belatedly and with some reservations, he takes up exotic themes that were never familiar to him, and at the same time pioneers a new technique.

POND AT VILLE-D'AVRAY
WITH LEANING TREE

Oil on canvas, $16^7/_8 \times 25^5/_8''$

Musée des Beaux-Arts, Reims

Moreau-Nélaton was merely stating the facts when he wrote: "Providence created Ville-d'Avray for Corot, and Corot for Ville-d'Avray." Never have the ties between man and nature been closer. Scarcely a year passed that the artist did not exhibit at least one painting of this site, to him an inexhaustible source of inspiration.

This is but one of many views Corot painted of the Ville-d'Avray ponds at intervals throughout his life. It is listed as No. 2062 in Robaut's catalogue. By 1873, Robaut never left the old master's side, and had begun preparations for his great biographical study, eventually published on the thirtieth anniversary of Corot's death.

Like *Le Catalpa* of 1869, this painting was executed at Ville-d'Avray in the last years of the artist's life. We have every reason to suppose that both these works were at least in part done from nature. Here Corot combined the poetry of remembered scenes with realistic observation. But it was the delicate trees, the soft clouds, the mist and dew of the morning that always attracted him most.

We are here far removed from Corot's youthful renderings of the same region, such as *The Cabassud Houses at Ville-d'Avray*.

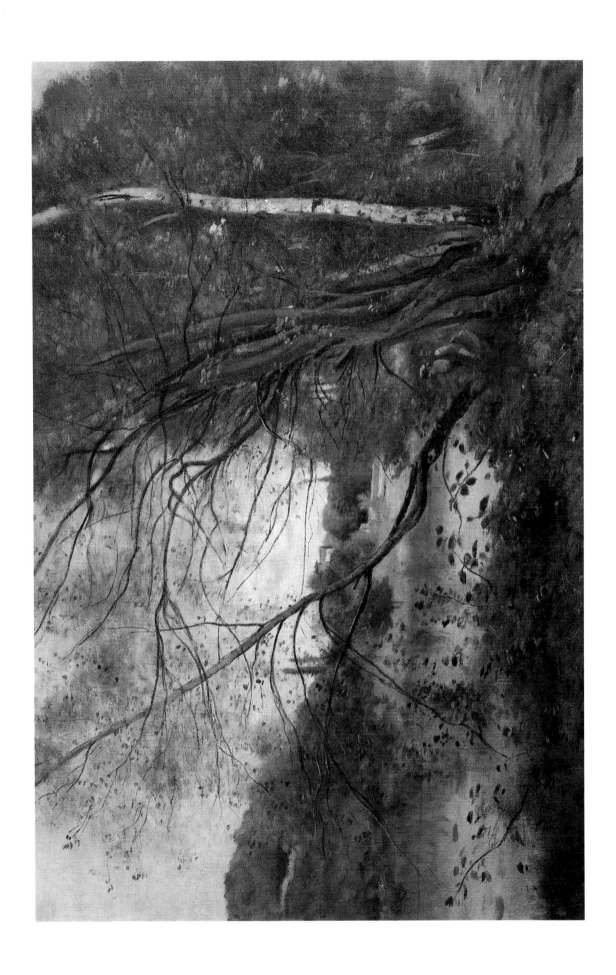

INTERIOR OF SENS CATHEDRAL

Oil on canvas, 24 × 15³/₄"

The Louvre, Paris

This picture was painted in September, 1874, during three sessions in the cathedral itself. The artist was seventy-eight, and it seems that this was the last work he painted outside the studio.

Its mastery is flawless, showing no trace of declining powers. The drawing is precise, the composition harmonious, and the light justifies Claude Monet's judgment that Corot was the master of the Impressionists. This painting has given rise to the most varied reactions. In the catalogue to the Bonington exhibition (Musée Jacquemart-André, Paris, 1966), Pierre Georgel observes that the work has a Romantic character and that Corot was influenced by Bonington; he emphasizes the affinity between this painting and Bonington's *Interior of the Cathedral,* which dates from 1822. For other writers, the work is already Impressionist because of the essential role played by the light.

Certainly Corot, just a few months before his death, was not consciously setting out to make innovations. It is equally certain that he was motivated here solely by his pleasure in painting, and that his mastery is complete. Like *The Belfry of Douai,* this work combines the keenest observation and a hand of unmatched skill. The figures have a truth and poetry rarely equalled in Corot's works; one need only compare them with the silhouettes that animate the early compositions—silhouettes a little awkward, adequate for indicating scale, but with little or no individuality. The comparison helps to demonstrate the distance traveled by the artist in his long career.

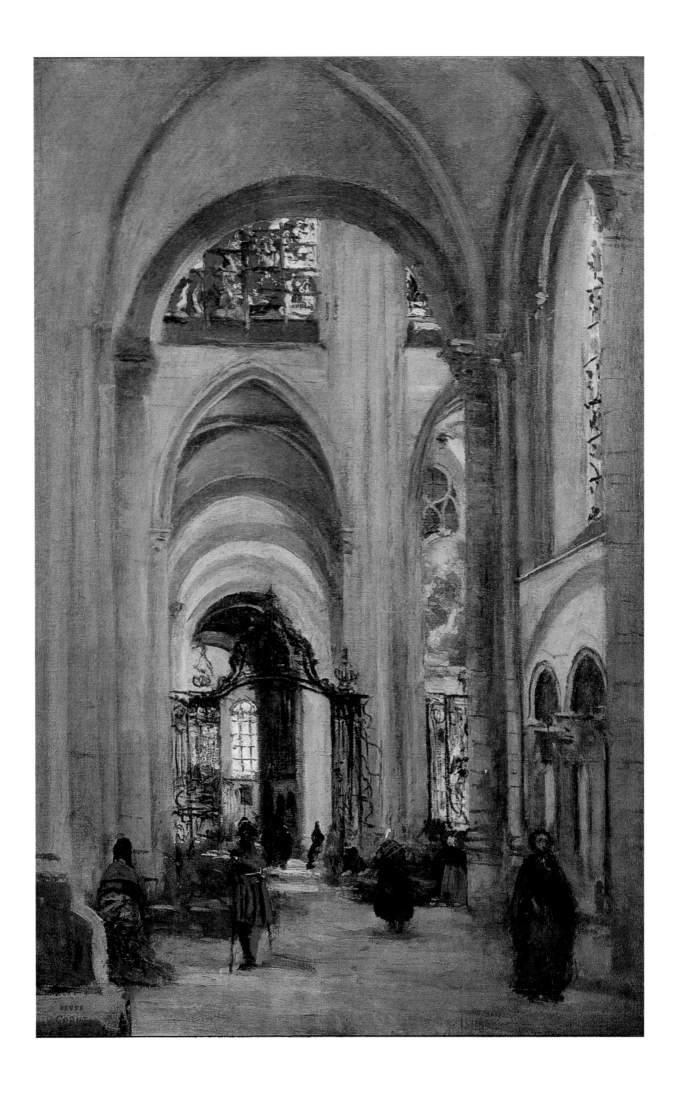

LADY IN BLUE

Oil on canvas, $31^1/_2 \times 19^5/_8''$

The Louvre, Paris

This is probably the last figure painting Corot executed. Though signed and dated 1874, that is to say only a few months before his death, it represents a new accent in his work. There is hardly a more beautiful figure than this one. It foreshadows Impressionism, and had an obvious influence on Renoir, who painted his portrait of Mme Hartmann the same year.

Here we have a young woman in an evening gown; her face, turned toward the viewer, suggests a very attractive personality and a state of mind and feeling very much her own, which sets her apart from the deliberately impersonal allegories of melancholy reverie painted by Corot in previous years. According to Bernheim de Villers, who has made a special study of Corot's figures, this is a portrait of Mme G—, a friend of Corot's, and not of a casual model. The young woman is shown leaning against a console or piano, and holding a fan. A frame placed against the wall, and the two sketches, suggest that we are in Corot's apartment in the same building where he had his studio. There is a silence, a restraint, and a dim light which are out of keeping with the studio itself.

We know how much Degas admired Corot, and this work helps us better to see why, for it is filled with a feeling of understanding and a melancholy shared by the two artists.

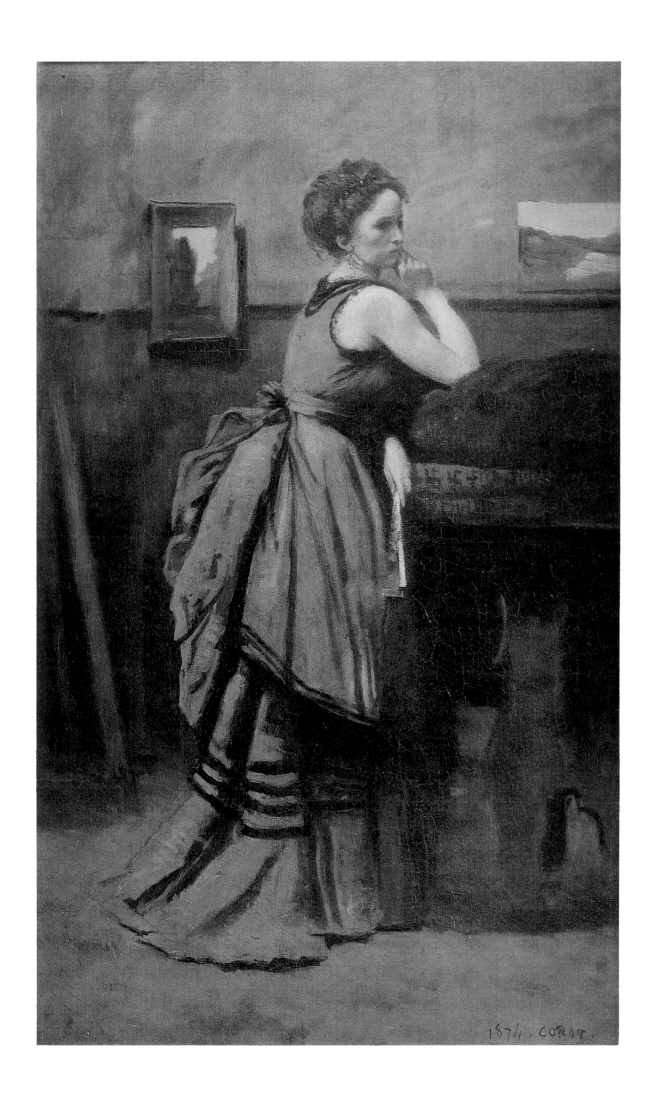